Design and layout by Ryo Sanada and Suridh Hassan

ISBN: 978-1-7393867-0-2
Printed in the UK

@bombstagram
www.stickerbombworld.com
www.soibooks.com

TIFO

THE ART OF
FOOTBALL FAN STICKERS

Ryo Sanada & Suridh Hassan

SOI BOOKS

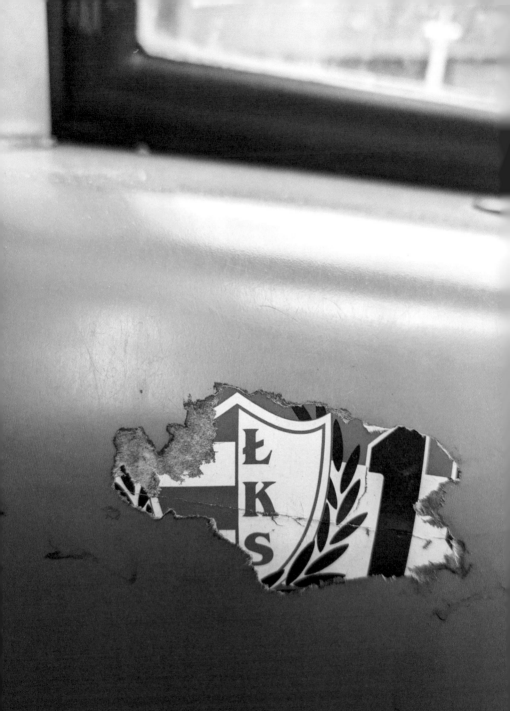

A peeled-off sticker on a London bus's top deck reveals ŁKS Łódź: a Polish football club with a storied history, dedicated youth development, and strong community ties.

CONTENTS

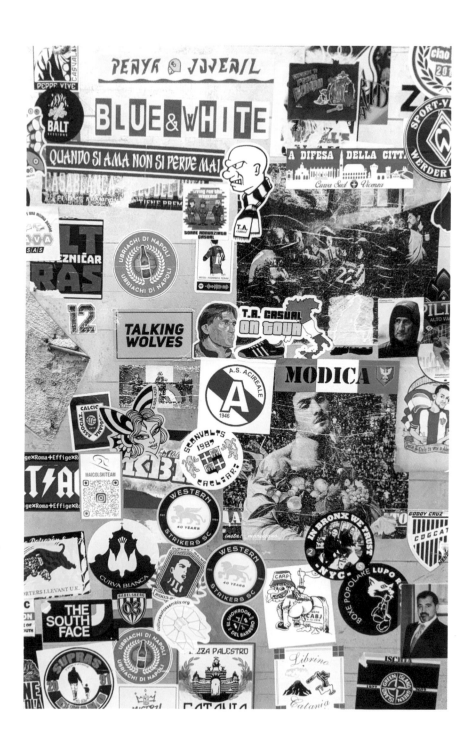

INTRODUCTION

As football fans immersed in the world of documentaries, television production, commercials and design, our passion has always intertwined with our profession.

Our journey in creating this book began quite casually, taking pictures of unique football stickers across Europe during family holidays. The pleasure we took in discovering the stories behind the stickers gradually spiralled into something deeper.

Our first idea was to create a sticker book. We've done this before with our popular Stickerbomb sticker book series; but this book's focus eventually shifted to something more documentary and archival. We decided to take lots of pictures of stickers and create a design art book.

We quickly realised several things. One was that stickers are a way for fans to express themselves, especially when travelling. They communicate with humour and share stories, encapsulating the essence of fan culture in all its diversity and enriching football fandom.

Through stickers, we discovered the story of clubs like Eastbourne FC on the south coast of England and their commitment to inclusivity. We learned about corporate corruption at Parma—a massive club during my childhood. I had always wondered what happened. And we were deeply touched when we came upon the friendship between Aberdeen FC and Boavista, fostered by a single Scotsman.

We extend our heartfelt thanks to best-selling author James Montague for his wonderful words on 1312/ ACAB, and to Eleanor Watson from the Design Museum, who curated Football: Designing the Beautiful Game, for her contribution. Their insights have greatly enriched this book.

Our efforts to connect with fan groups and clubs elicited varied reactions, from enthusiastic approval to incredulity and even outright disdain. Whatever the reaction, we've striven to represent the spirit of fandom with integrity. To those clubs not featured in this edition, fear not; plans for a second volume are underway, aiming to expand our narrative to include stories from South America, Africa, Asia, and beyond.

Welcome to a world where every sticker tells a story, inviting us to a deeper appreciation of the beautiful game.

Suridh Hassan and Ryo Sanada

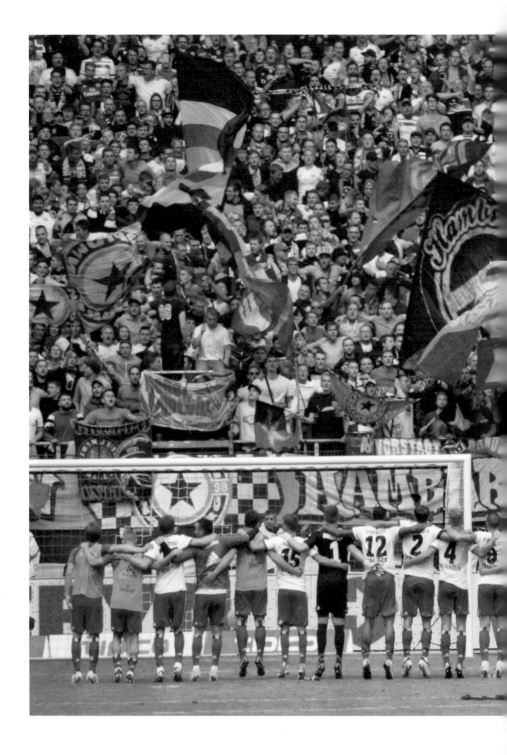

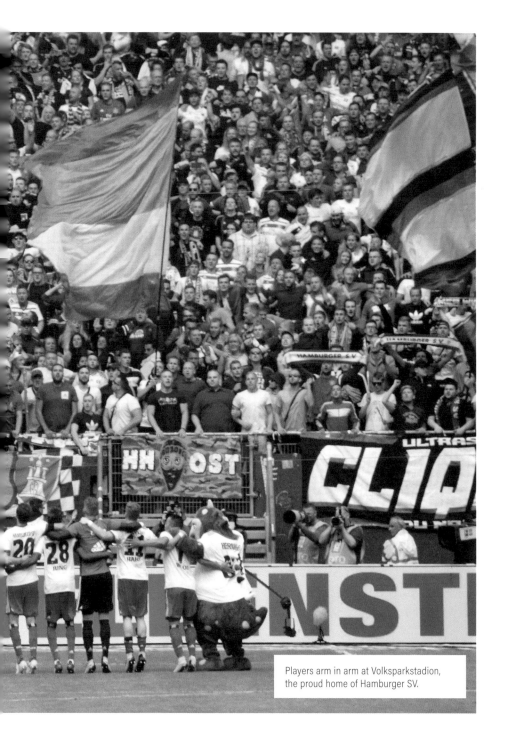

Players arm in arm at Volksparkstadion, the proud home of Hamburger SV.

FOOTBALL GRAPHICS: A GALLOPING OVERVIEW

ELEANOR WATSON

Like many things in life, football graphics have surprisingly mundane origins. What is today an incredibly rich and complex sphere of visual communication originated in the late 19th century as a simple practical need: to identify players on the pitch. This was as important for those playing as for spectators watching from a distance, and led to the development of two separate but equally important elements, the crest and the kit.

Though we may struggle to picture it now, there was once a time where there was no money in football and competitive teams played for free in their ordinary work boots and shirts. Football jerseys did not exist, and a kit was created by the player simply stitching a basic symbol such as a heart, cross or skull onto their shirt ahead of the match, which they could then remove afterwards. Team photographs of the 1870s and 1880s offer moving, and at times amusing, evidence of this DIY spirit, with solemn-faced players grouped together in a melee of hooped socks and mismatched shirts, the wobbly star on their chest being the only unifying element. As the game was professionalised, teams became closely associated with the stadium they played in and the community that they represented. The simple geometry of the hand-made badge made way for increasingly elaborate crests that were professionally produced, often featuring the town or city coat of arms. Local industry and buildings were also common sources of inspiration, and they continue to act as symbols for clubs today, even when the landmarks no longer exist. The most recent developments in crest design have focused on their need to perform in

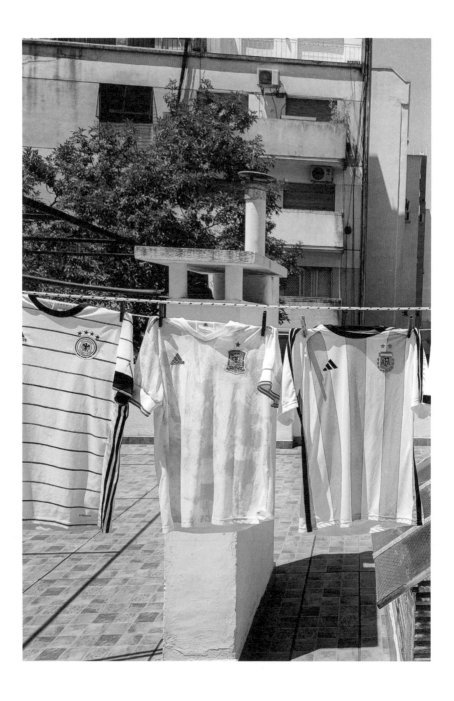

a digital setting. As the overwhelming majority of football fans engage with the game on-screen, many crests have been streamlined to accommodate a huge variation in resolution and scale, while also jostling to attract global audiences.

The second crucial element in football graphics is the kit, by which we fundamentally mean the team colours. The kit is again rooted in the practical need for identification, which goes some way in explaining the dominating presence of red and blue – colours that contrast well with each other but also with the green of the pitch. Initially applied as a block colour or in simple patterns such as stripes or checkerboards, the team colours were imaginatively reinterpreted as material innovations opened up possibilities within kit design throughout the 20th century. Sober designs in cotton, flannel and wool gradually gave way to the explosion of form and colour made possible by the development of synthetic materials in the 1970s. Today, complex printing processes allow for ever more subtle detailing, with the graphic interpretation of a team's identity being a crucial, and highly publicised, aspect of the design process.

It is neat, and somehow reassuring, to be able to trace a simple history of football design through official changes in the kit and crest. Much harder, but I suspect infinitely more rewarding, would be to map the prodigious graphic output of fans, who also use these two simple building blocks, but to dazzlingly diverse effect. From the earliest days of the game, far more people have watched football than played it. It has not been a passive spectatorship however, and though football fans are consistently represented and treated firstly as consumers, they are in fact a formidable and largely unrecognised part of the design ecosystem. Their outputs are innumerable: banners, rosettes, pyrotechnic displays, chants, fanzines, badges, hooligan cards, scrapbooks, customised jerseys, terrace fashions, fan spaces, choreographies, marches, books, shrines, tabletop games, video games, stat reports, Youtube compilations, cakes, tattoos, campaigns. And of course stickers. In a space often no larger than a mobile phone, fans manage to collapse an entire world of football culture, subverting and enhancing existing language and symbols to better capture the identity of their club, their community and themselves. These designs are rarely compiled and stored away for posterity, yet they become part of official history as they are absorbed by the football industry in their endless quest to release newer, more authentic, products. It is a cycle of mutual influence with no end.

It is a rare pleasure to be able to admire these original designs first hand in the compilation that follows. While the objects themselves are small, unassuming, and temporal, they somehow capture the fan culture's own crucial elements: creativity, irreverence and care.

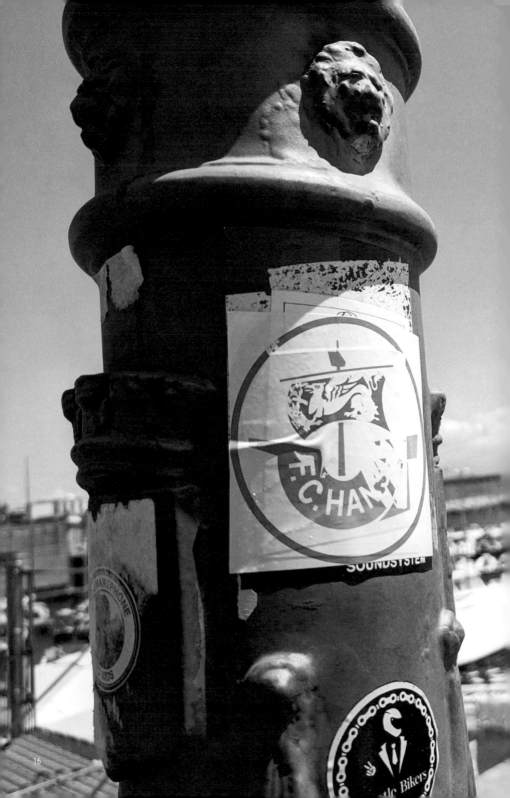

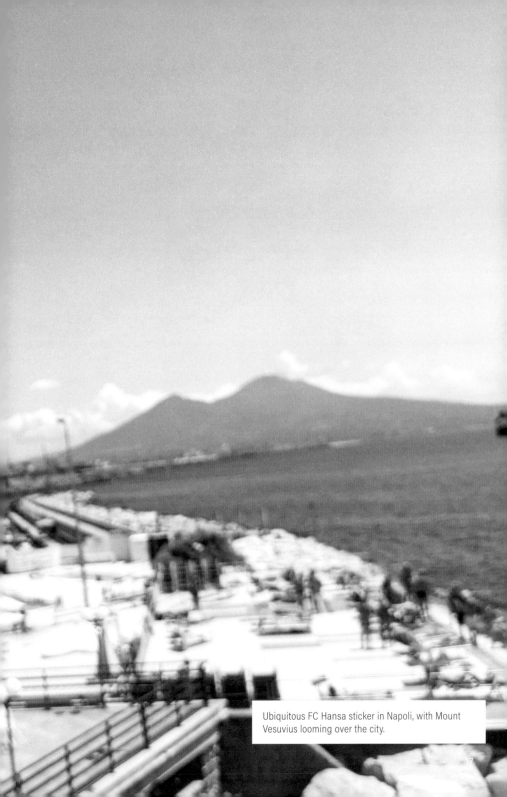

Ubiquitous FC Hansa sticker in Napoli, with Mount Vesuvius looming over the city.

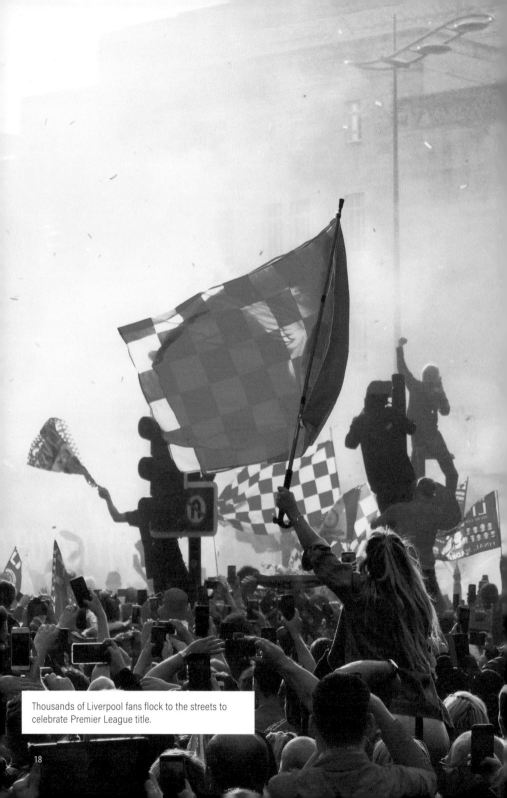

Thousands of Liverpool fans flock to the streets to celebrate Premier League title.

THE BRITISH ISLES

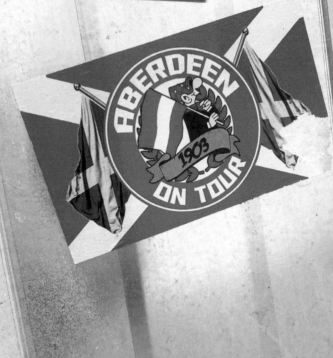

Stand Free: Aberdeen and Boavista
Both established in 1903, Boavista and Aberdeen share a rich footballing history. In 2022, the Aberdeen community mourned the loss of Dave Geddie, a devoted supporter pivotal in fostering the bond between Aberdeen and Boavista. After befriending a young Portuguese Boavista fan studying in Aberdeen, Geddie led a group of Aberdeen supporters to support Boavista in the Porto derby, and frequent fan exchanges between the two clubs followed. When they learned of his passing, Aberdeen and Boavista fans united in unfurling banners to honour his memory.

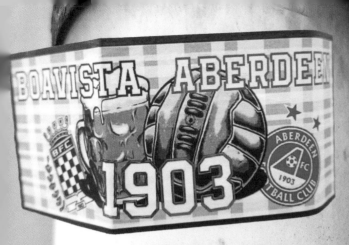

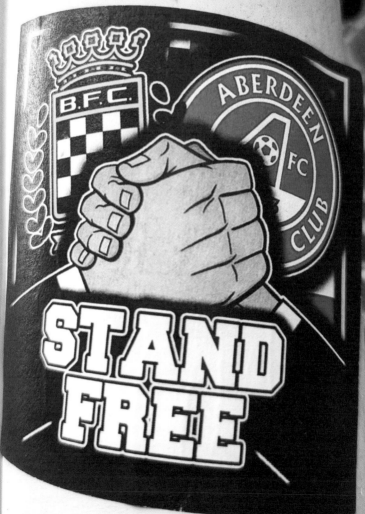

I JUST DON'T THINK YOU UNDERSTAND

ARSENAL WFC

IN THAT ORDE

OVER AND OVER AGAIN OVER AND OVER AGAIN

NORTH LONDON

WE ALL FOLLOW THE ARSENAL

OVER LAND AND SEA

SNIFFING LINES

BANGING NINES

EST. 2001

SAKA

ASNL
LDN

HIGHBURY HILL

A
F C

SOCIAL

MARTINELLI

A Glimpse Inside: Arsenal at the Emirates Stadium

IS YOURS GOLD

Is Yours Gold?
A sticker referencing the golden Premier League trophy which the "Invincibles" Arsenal team won in the 2003-2004 season. Only two clubs have ever gone the full top flight season in England without a single loss: Arsenal and the Preston North End team of the 1888-1889 season.

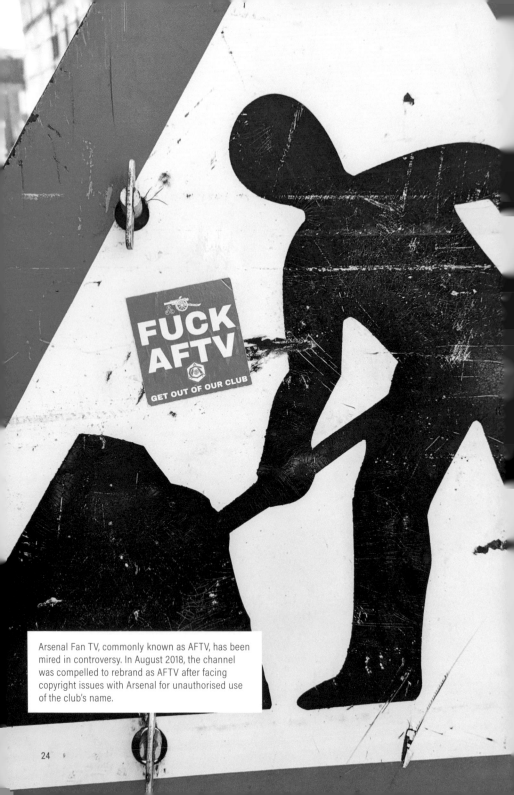

Arsenal Fan TV, commonly known as AFTV, has been mired in controversy. In August 2018, the channel was compelled to rebrand as AFTV after facing copyright issues with Arsenal for unauthorised use of the club's name.

AVFC

THE VILLA BOYS FROM ASTON

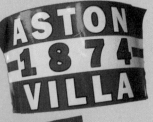

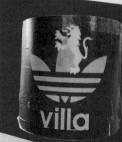

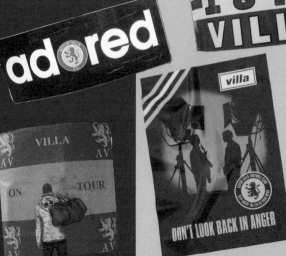

Villa Park is the home of Aston Villa and the largest football stadium in the English Midlands, with a current seating capacity of 42,650.

BIRMINGHAM CITY

18 ⇄ **75**

KEEP RIGHT ON

SHIT ON THE V*LLA

ZULU WARRIORS

Z

B.C.F.C.

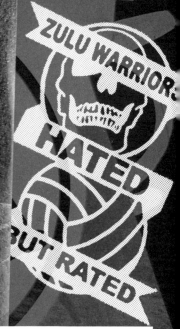

ZULU WARRIORS

RATED

BUT RATED

BIRMINGHAM CITY

SHIT ON THE

VILLA

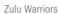

SHUT ELBIT DOWN

Zulu Warriors
The Zulus were a hooligan fan group founded in 1982, at the height of English football's hooligan scene. The Zulus were unique because they were a multiethnic fan group at a time when most hooligan groups were exclusively white, English and politically right-wing. The name is said to have originated during a game against Manchester City, when their fans chanted "Zulu" at the Birmingham fans. Meant as a racial insult, the Birmingham fans instead chose to adopt the name for their group.

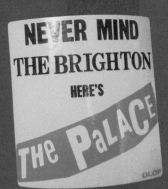

NEVER MIND THE BRIGHTON HERE'S THE PaLACE

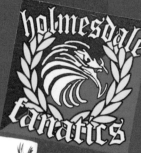

holmesdale fanatics

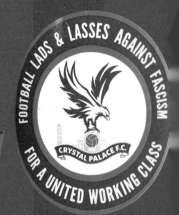

FOOTBALL LADS & LASSES AGAINST FASCISM FOR A UNITED WORKING CLASS

CRYSTAL PALACE F.C.

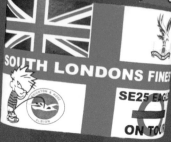

SOUTH LONDONS FINES
SE25 EAGL
ON TOU

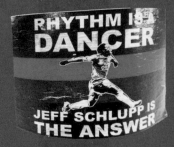

RHYTHM IS A DANCER
JEFF SCHLUPP IS THE ANSWER

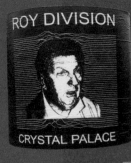

ROY DIVISION
CRYSTAL PALACE

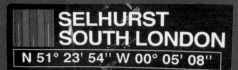

SELHURST SOUTH LONDON
N 51° 23' 54" W 00° 05' 08"

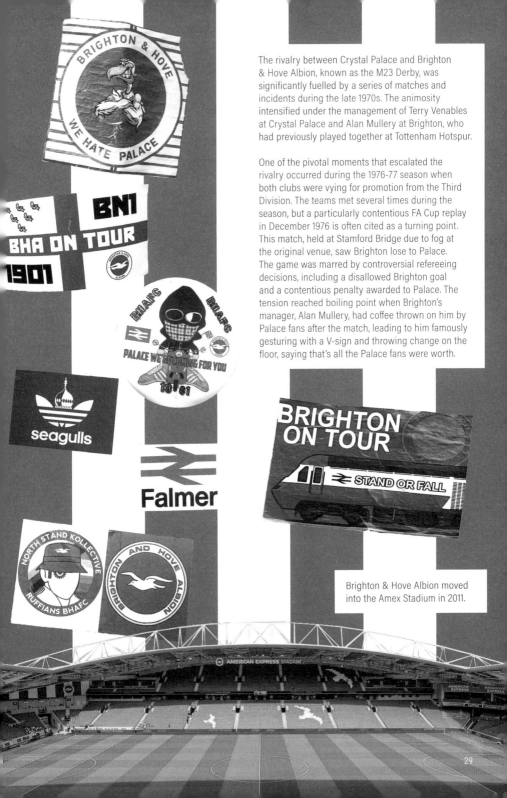

BRIGHTON & HOVE
WE HATE PALACE

BN1
BHA ON TOUR
1901

PALACE WE'RE COMING FOR YOU

seagulls

Falmer

BRIGHTON
ON TOUR
STAND OR FALL

The rivalry between Crystal Palace and Brighton & Hove Albion, known as the M23 Derby, was significantly fuelled by a series of matches and incidents during the late 1970s. The animosity intensified under the management of Terry Venables at Crystal Palace and Alan Mullery at Brighton, who had previously played together at Tottenham Hotspur.

One of the pivotal moments that escalated the rivalry occurred during the 1976-77 season when both clubs were vying for promotion from the Third Division. The teams met several times during the season, but a particularly contentious FA Cup replay in December 1976 is often cited as a turning point. This match, held at Stamford Bridge due to fog at the original venue, saw Brighton lose to Palace. The game was marred by controversial refereeing decisions, including a disallowed Brighton goal and a contentious penalty awarded to Palace. The tension reached boiling point when Brighton's manager, Alan Mullery, had coffee thrown on him by Palace fans after the match, leading to him famously gesturing with a V-sign and throwing change on the floor, saying that's all the Palace fans were worth.

Brighton & Hove Albion moved into the Amex Stadium in 2011.

29

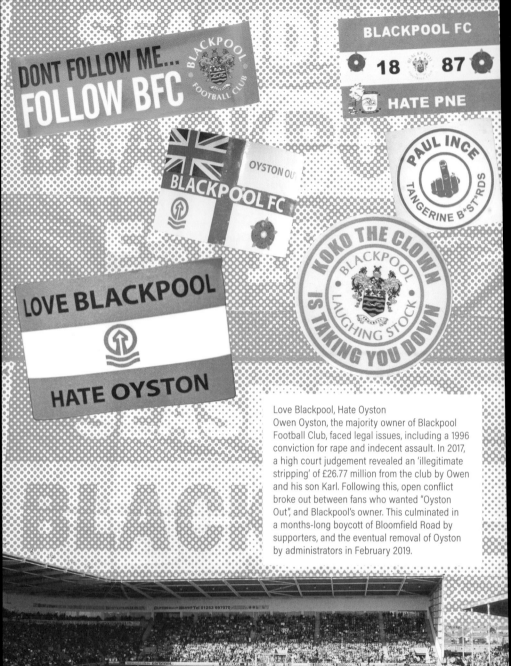

DONT FOLLOW ME...
FOLLOW BFC

BLACKPOOL FOOTBALL CLUB

BLACKPOOL FC

18 87

HATE PNE

OYSTON OUT

BLACKPOOL FC

PAUL INCE
TANGERINE B*ST*RDS

LOVE BLACKPOOL

HATE OYSTON

KOKO THE CLOWN
BLACKPOOL
LAUGHING STOCK
IS TAKING YOU DOWN

Love Blackpool, Hate Oyston

Owen Oyston, the majority owner of Blackpool Football Club, faced legal issues, including a 1996 conviction for rape and indecent assault. In 2017, a high court judgement revealed an 'illegitimate stripping' of £26.77 million from the club by Owen and his son Karl. Following this, open conflict broke out between fans who wanted "Oyston Out", and Blackpool's owner. This culminated in a months-long boycott of Bloomfield Road by supporters, and the eventual removal of Oyston by administrators in February 2019.

Bloomfield Road, home of Blackpool FC since 1901.

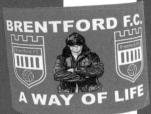

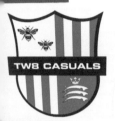

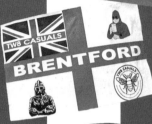

Brentford FC moved to the Gtech Community Stadium at the start of the 2020/21 season.

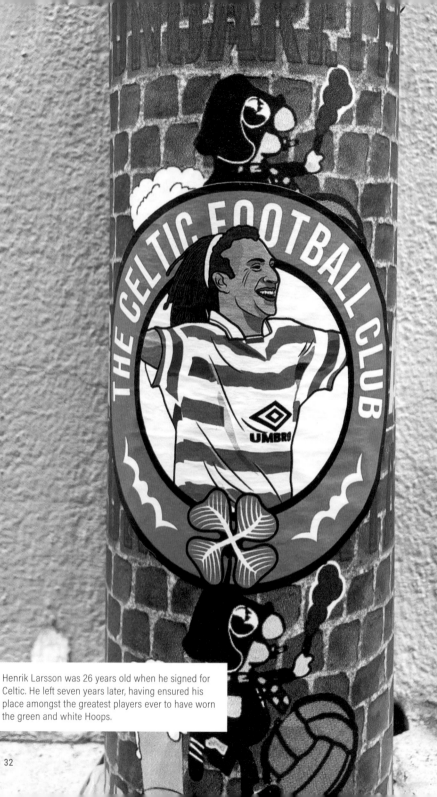

Henrik Larsson was 26 years old when he signed for Celtic. He left seven years later, having ensured his place amongst the greatest players ever to have worn the green and white Hoops.

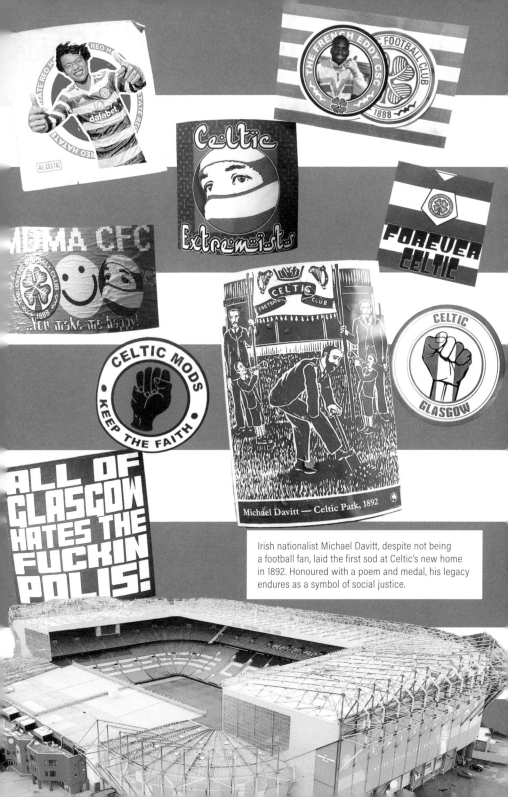

Irish nationalist Michael Davitt, despite not being a football fan, laid the first sod at Celtic's new home in 1892. Honoured with a poem and medal, his legacy endures as a symbol of social justice.

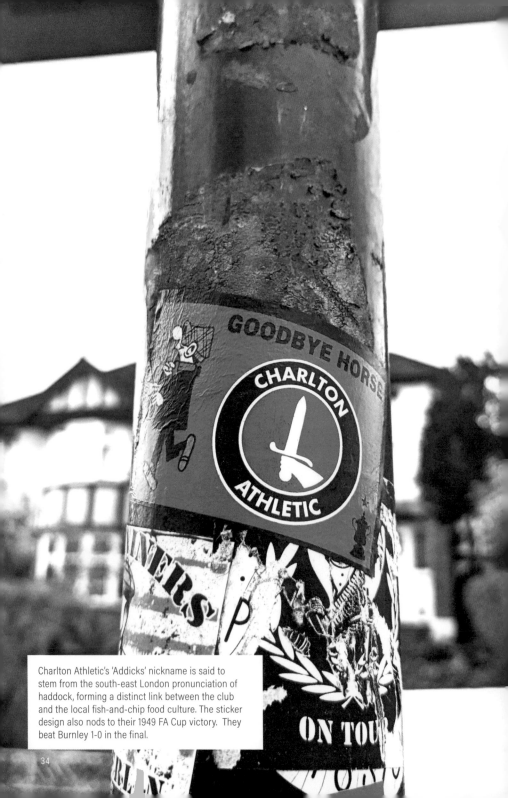

Charlton Athletic's 'Addicks' nickname is said to stem from the south-east London pronunciation of haddock, forming a distinct link between the club and the local fish-and-chip food culture. The sticker design also nods to their 1949 FA Cup victory. They beat Burnley 1-0 in the final.

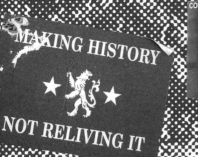

MAKING HISTORY

NOT RELIVING IT

COKE-SNIFFING APPRENTICE TOMMY-BOYS AND THEIR FAT DADS

CHELSEA F.C.

HAVE A LOOK

AT MY FROZEN ASSETS

JOHN OBI MIKEL

THE AFRICAN ZIDANE

SAMSUNG

CASUAL CHELSEA

WE SEE THINGS

THEY'LL NEVER SEE

THE PRIDE OF LONDON SINCE 1905

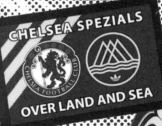

CHELSEA SPEZIALS

CHELSEA FOOTBALL CLUB

OVER LAND AND SEA

CHELSEA FOOTBALL CLUB

RUINING FOOTBALL SINCE 2003

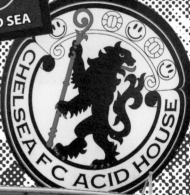

CHELSEA FC ACID HOUSE

Stamford Bridge: The Historic Fortress of Chelsea FC

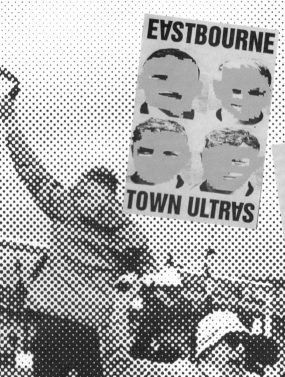

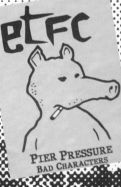

PIER PRESSURE
BAD CHARACTERS

Eastbourne Town FC fans are a breed apart. The Pier Pressure Ultras, inspired by Italy's passionate fan culture, emerged in 2017 from locals disenchanted with modern football. They're not just supporters, they're community activists, raising funds for charities and championing diversity. Their creativity shines through in striking graphics featuring Quasimoto and dynamic graffiti-style designs. For Eastbourne Town FC, Pier Pressure Ultras are more than fans – they're a vibrant force for change and artistic expression.

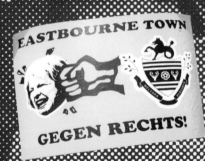

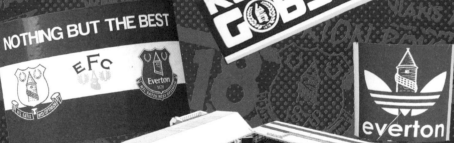

EVERTON

KOPITES ARE GOBSHITES

NOTHING BUT THE BEST

E F c
Everton

everton

Goodison Park to Pass the Torch to Everton Stadium for the 2025–26 Season.

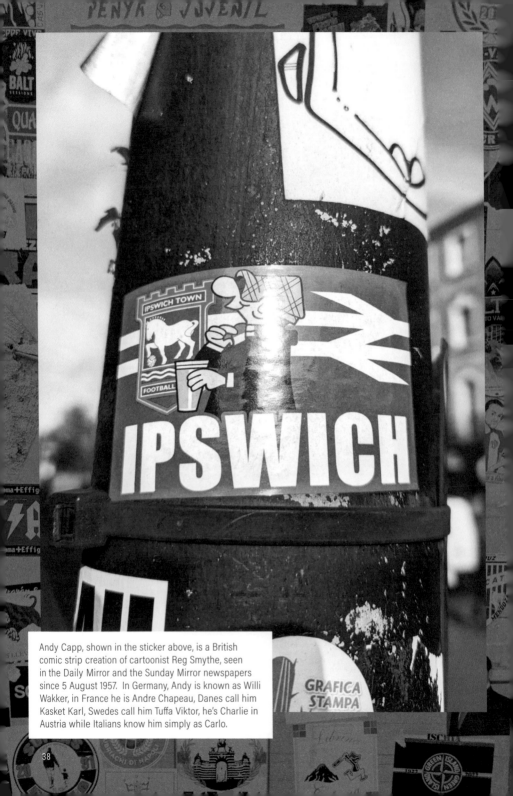

Andy Capp, shown in the sticker above, is a British comic strip creation of cartoonist Reg Smythe, seen in the Daily Mirror and the Sunday Mirror newspapers since 5 August 1957. In Germany, Andy is known as Willi Wakker, in France he is Andre Chapeau, Danes call him Kasket Karl, Swedes call him Tuffa Viktor, he's Charlie in Austria while Italians know him simply as Carlo.

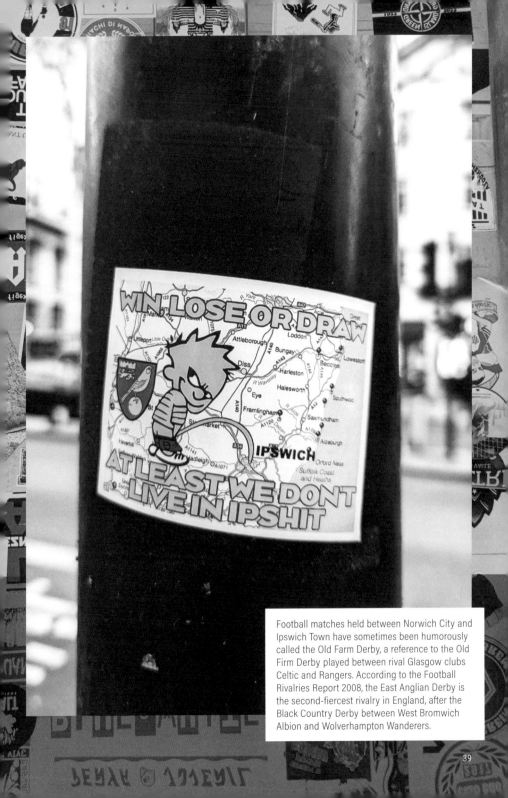

Football matches held between Norwich City and Ipswich Town have sometimes been humorously called the Old Farm Derby, a reference to the Old Firm Derby played between rival Glasgow clubs Celtic and Rangers. According to the Football Rivalries Report 2008, the East Anglian Derby is the second-fiercest rivalry in England, after the Black Country Derby between West Bromwich Albion and Wolverhampton Wanderers.

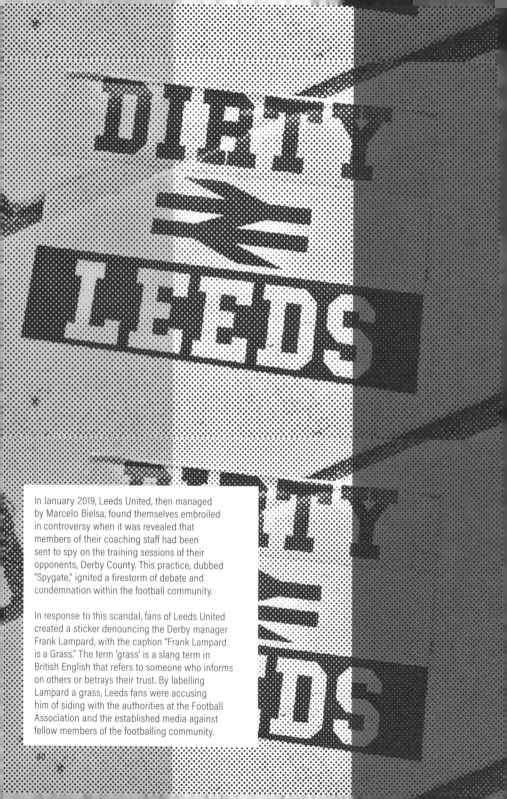

In January 2019, Leeds United, then managed by Marcelo Bielsa, found themselves embroiled in controversy when it was revealed that members of their coaching staff had been sent to spy on the training sessions of their opponents, Derby County. This practice, dubbed "Spygate," ignited a firestorm of debate and condemnation within the football community.

In response to this scandal, fans of Leeds United created a sticker denouncing the Derby manager Frank Lampard, with the caption "Frank Lampard is a Grass." The term 'grass' is a slang term in British English that refers to someone who informs on others or betrays their trust. By labelling Lampard a grass, Leeds fans were accusing him of siding with the authorities at the Football Association and the established media against fellow members of the footballing community.

FRANK LAMPARD IS A GRASS

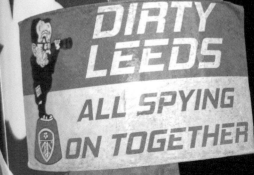

DIRTY LEEDS
ALL SPYING
ON TOGETHER

Naissance Musik

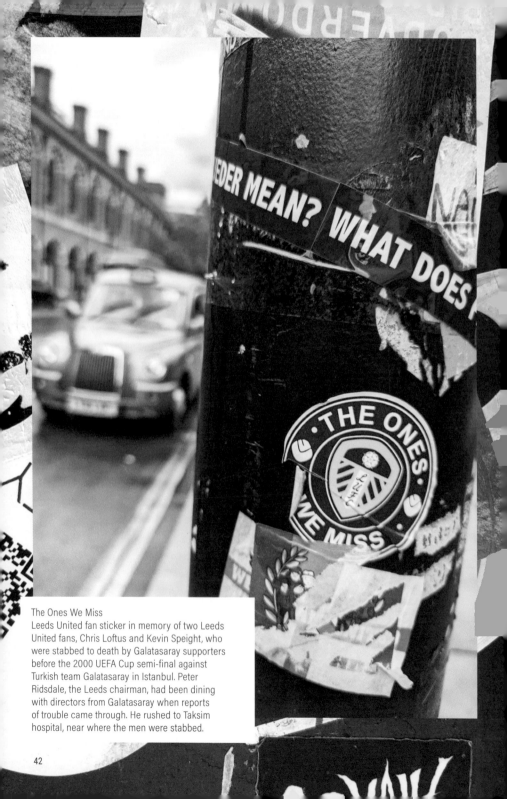

The Ones We Miss
Leeds United fan sticker in memory of two Leeds United fans, Chris Loftus and Kevin Speight, who were stabbed to death by Galatasaray supporters before the 2000 UEFA Cup semi-final against Turkish team Galatasaray in Istanbul. Peter Ridsdale, the Leeds chairman, had been dining with directors from Galatasaray when reports of trouble came through. He rushed to Taksim hospital, near where the men were stabbed.

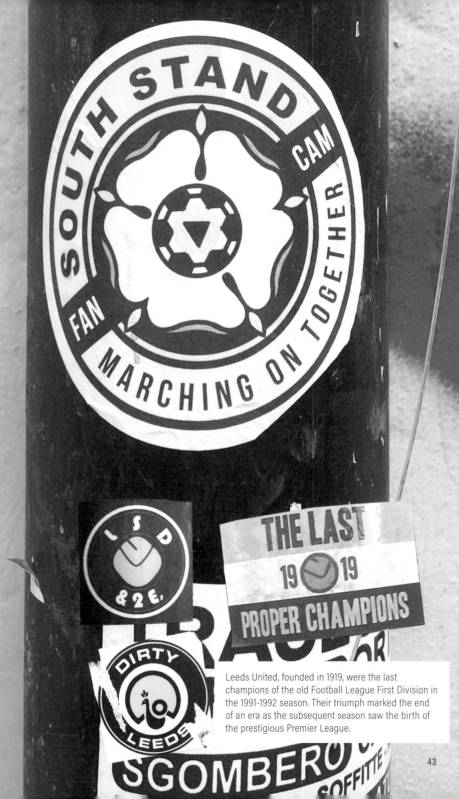

Leeds United, founded in 1919, were the last champions of the old Football League First Division in the 1991-1992 season. Their triumph marked the end of an era as the subsequent season saw the birth of the prestigious Premier League.

Sock robbing cunts

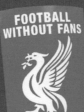

FOOTBALL WITHOUT FANS

IS NOTHING

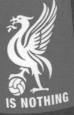

THE TRUTH WAS PROVED

SHUN THE ~~SUN~~

NOT WELCOME HERE

DON'T BUY TH

96 JUSTICE FOR ALL

Hillsborough Justice Campa

liverpool ORIGINALS

YOU SCOUSE BASTARD IS A COMPLIMENT

FOOTBALL LADS & LASSES AGAINST FASCISM

FOR A UNITED WORKING CLASS

L.F.C.

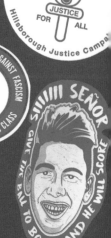

SIIIIII SENOR GIVE THE BALL TO BOBBY AND HE WILL SCORE

OLSC RED FELLAS AUSTRIA

WE FOLLOW OUR BIRD EVERYWHERE

RF

LEN NON WAS A RED

Instagram: @wb_cooper @glass_tiles

LIVERPOOL THE CREAM OF EUROPE ★★★★★

SPION KOP 19 06

LIVERPOOL

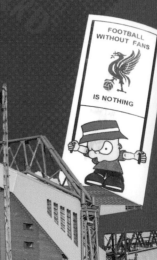

FOOTBALL WITHOUT FANS

IS NOTHING

Anfield: The Iconic Heartbeat of Liverpool FC

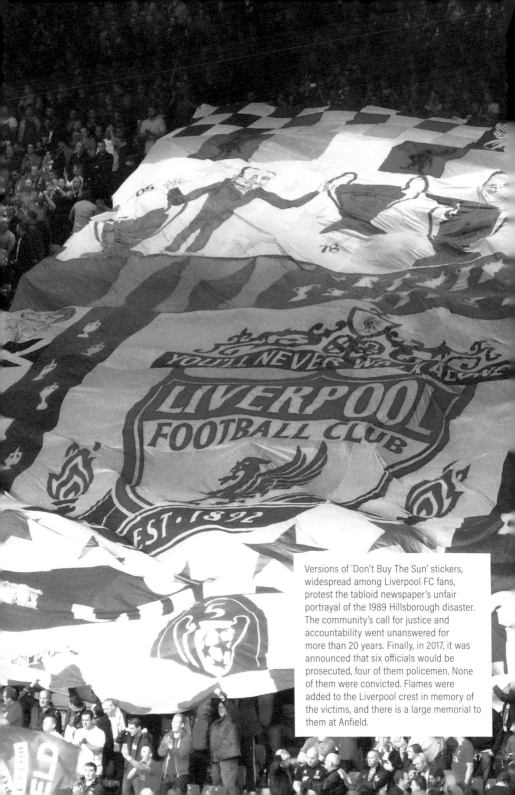

Versions of 'Don't Buy The Sun' stickers, widespread among Liverpool FC fans, protest the tabloid newspaper's unfair portrayal of the 1989 Hillsborough disaster. The community's call for justice and accountability went unanswered for more than 20 years. Finally, in 2017, it was announced that six officials would be prosecuted, four of them policemen. None of them were convicted. Flames were added to the Liverpool crest in memory of the victims, and there is a large memorial to them at Anfield.

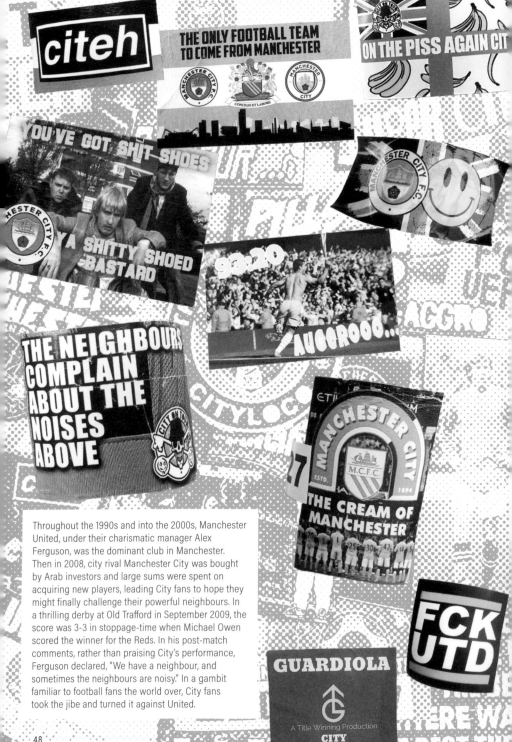

citeh

THE ONLY FOOTBALL TEAM TO COME FROM MANCHESTER

ON THE PISS AGAIN CIT

YOU'VE GOT SHIT SHOES

A SHITTY SHOED BASTARD

93:20

AGUEROOO...

THE NEIGHBOURS COMPLAIN ABOUT THE NOISES ABOVE

MANCHESTER CITY
M.C.F.C.
ESTD. 1894
THE CREAM OF MANCHESTER

FCK UTD

Throughout the 1990s and into the 2000s, Manchester United, under their charismatic manager Alex Ferguson, was the dominant club in Manchester. Then in 2008, city rival Manchester City was bought by Arab investors and large sums were spent on acquiring new players, leading City fans to hope they might finally challenge their powerful neighbours. In a thrilling derby at Old Trafford in September 2009, the score was 3-3 in stoppage-time when Michael Owen scored the winner for the Reds. In his post-match comments, rather than praising City's performance, Ferguson declared, "We have a neighbour, and sometimes the neighbours are noisy." In a gambit familiar to football fans the world over, City fans took the jibe and turned it against United.

GUARDIOLA
A Title Winning Production
CITY

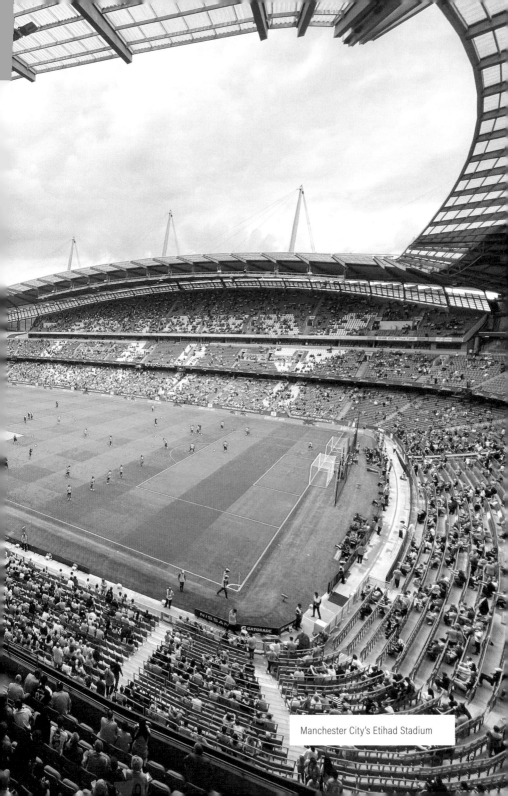

Manchester City's Etihad Stadium

The Glazer family acquired Manchester United in 2005 largely by taking out large loans secured against the assets of the club. This resulted in massive annual interest payments having to be taken from club finances, reducing necessary investment in the team and stadium. This example of what many traditional fans regard as modern football ownership, the bleeding dry of profitable clubs for personal enrichment, has led to continuing fan resistance at Old Trafford. In May 2021 10,000 supporters demonstrated outside the stadium before a game against rivals Liverpool. After 100 of them gained access to the pitch, the match had to be postponed.

MUFC

WEST GORTON REDS
WGR M12
MANCHESTER IS RED

BLEEDING UNITED DRY
#GLAZERSOUT

5CANTONAS
RALPHIE ONLINE ULTRAS

WE ARE UNITED
THE SALFORD AND MANCHESTER UNITED GROUP

'66 WAS A GREAT YEAR FOR ENGLISH FOOTBALL. ERIC WAS BORN.
RED ARMY

Gib R

ATTENTIE

Manchester is Red
MUFC FCUM
Tories go home!

LOVE UNITED HATE GLAZER

The French forward, Eric Cantona, became a cult hero at Old Trafford in the 1990s. He was notorious for kicking out at a fan after being sent off against Crystal Palace in 1995. On the sticker he is shown 'kicking' Margaret Thatcher, the recent Conservative party Prime Minister, out of Manchester.

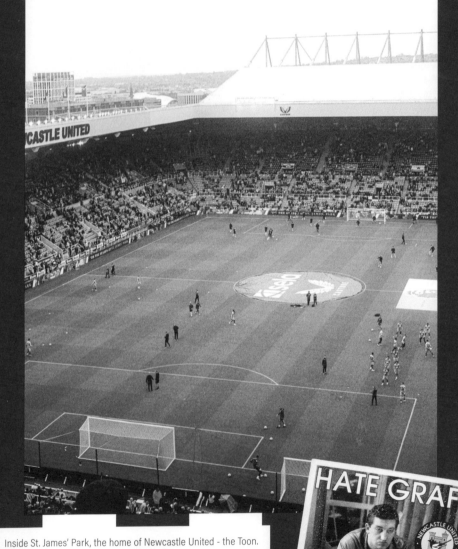

NE62

GUIDEPOST MAGS

1892

NEWCASTLE UNITED

HATE GRAFT

LOVE THE TOON

Inside St. James' Park, the home of Newcastle United - the Toon.

HOWAY THE WAY THE

GEORDIE BOOT BOYS

LA LA LA LA, GEORDIES

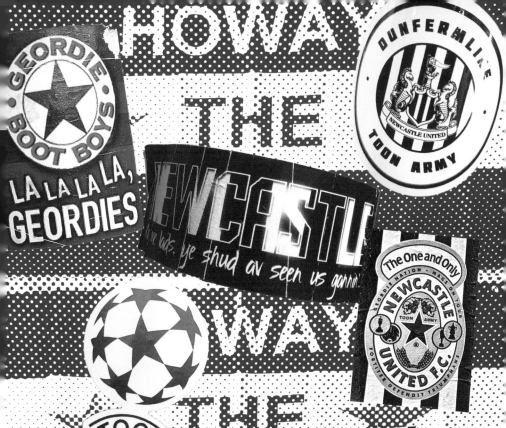

NEWCASTLE

ye shud av seen us gannin

DUNFERMLINE
NEWCASTLE UNITED
TOON ARMY

The One and Only
NEWCASTLE UNITED F.C.
TOON ARMY
FORTITER DEFENDIT TRIUMPHANS

TOON ARMY
GEORDIES ON TOUR

LEST WE FORGET

Mags on tour

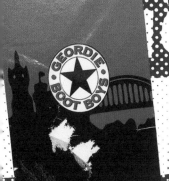

GEORDIE BOOT BOYS

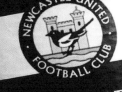

NEWCASTLE UNITED F.C
NEWCASTLE UNITED
FOOTBALL CLUB
FROM THE DESOLATE NORTH

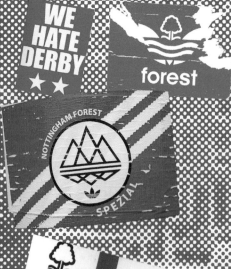

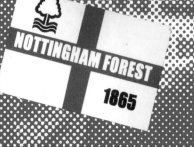

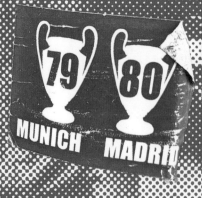

A sticker celebrating the illustrious history of Nottingham Forest FC who won the European Cup two years in a row under Brian Clough in 1979 and 1980.

"You win something once and people say it's down to luck... You win it twice and it shuts the buggers up."
- Brian Clough on back-to-back European Cup triumphs.

QUEENS
PARK
RANGERS
W12 ON TOUR

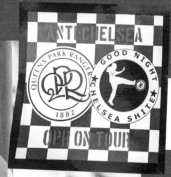

THE LOFT

IN YOUR TO
TAKING THE M

QPR
1882

JUSTICE FOR THE 72

QPR STANDS WITH GRENFELL

OH ME LADS,
YOU SHOULD OF SEEN US COMING.
RUNNING DOWN THE UXBRIDGE ROAD,
YOU SHOULD OF SEEN US COMING.
ALL THE LADS AND LASSES HAD
SMILES ON THEIR FACES,
RUNNING DOWN THE UXBRIDGE ROAD,
TO SEE THE QUEENS PARK RANGERS!

Justice for the 72
On the night of June 14, 2017, no more than a mile or so east of QPR's Loftus Road Stadium in west London, a fire broke out in a 24-storey high-rise block of flats. Seventy-two people died in what came to be known as the Grenfell Tower disaster. As details emerged of multiple health and safety issues that had been ignored by the local government over many years, fury with the authorities escalated amongst survivors and the local community, including supporters of QPR.

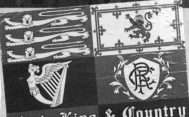

RANGERS ON TOUR

Club, King & Country

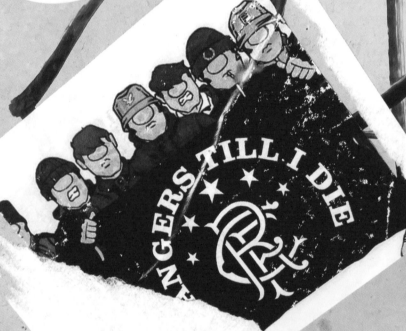

RANGERS TILL I DIE

REM CULT

GLASGOW IS BLUE! SINCE 1872.

BILLY BOYS

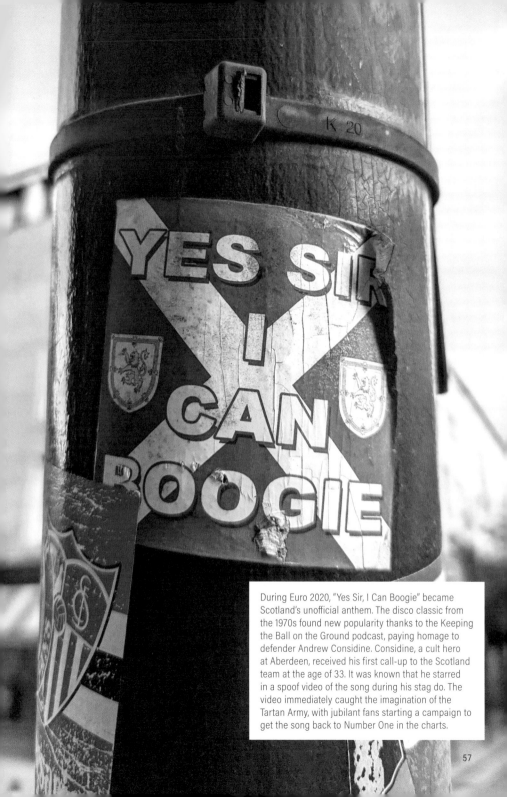

During Euro 2020, "Yes Sir, I Can Boogie" became Scotland's unofficial anthem. The disco classic from the 1970s found new popularity thanks to the Keeping the Ball on the Ground podcast, paying homage to defender Andrew Considine. Considine, a cult hero at Aberdeen, received his first call-up to the Scotland team at the age of 33. It was known that he starred in a spoof video of the song during his stag do. The video immediately caught the imagination of the Tartan Army, with jubilant fans starting a campaign to get the song back to Number One in the charts.

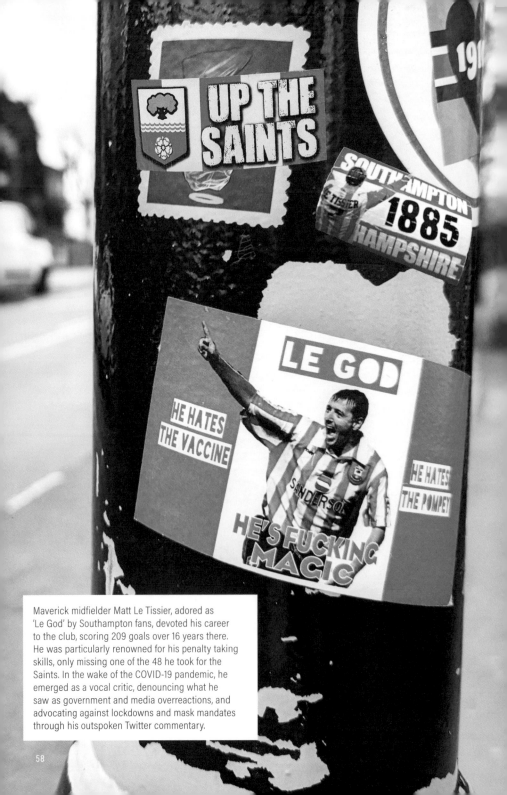

UP THE SAINTS

SOUTHAMPTON 1885 HAMPSHIRE

LE GOD

HE HATES THE VACCINE

HE HATES THE POMPEY

SANDERSON

HE'S FUCKING MAGIC

Maverick midfielder Matt Le Tissier, adored as 'Le God' by Southampton fans, devoted his career to the club, scoring 209 goals over 16 years there. He was particularly renowned for his penalty taking skills, only missing one of the 48 he took for the Saints. In the wake of the COVID-19 pandemic, he emerged as a vocal critic, denouncing what he saw as government and media overreactions, and advocating against lockdowns and mask mandates through his outspoken Twitter commentary.

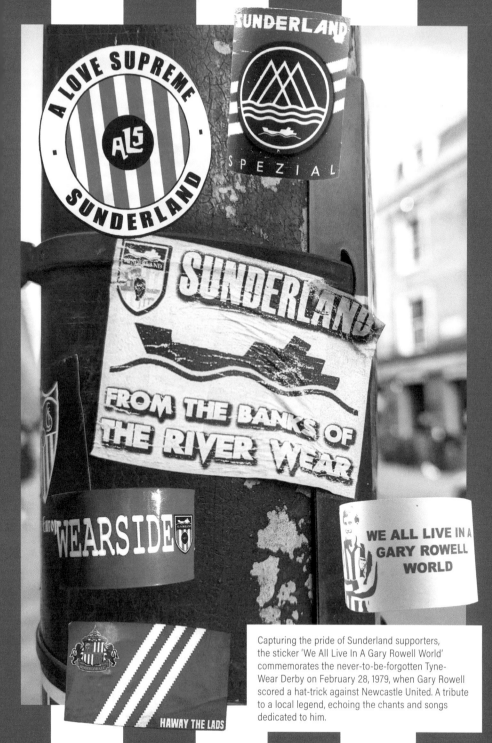

Capturing the pride of Sunderland supporters, the sticker 'We All Live In A Gary Rowell World' commemorates the never-to-be-forgotten Tyne-Wear Derby on February 28, 1979, when Gary Rowell scored a hat-trick against Newcastle United. A tribute to a local legend, echoing the chants and songs dedicated to him.

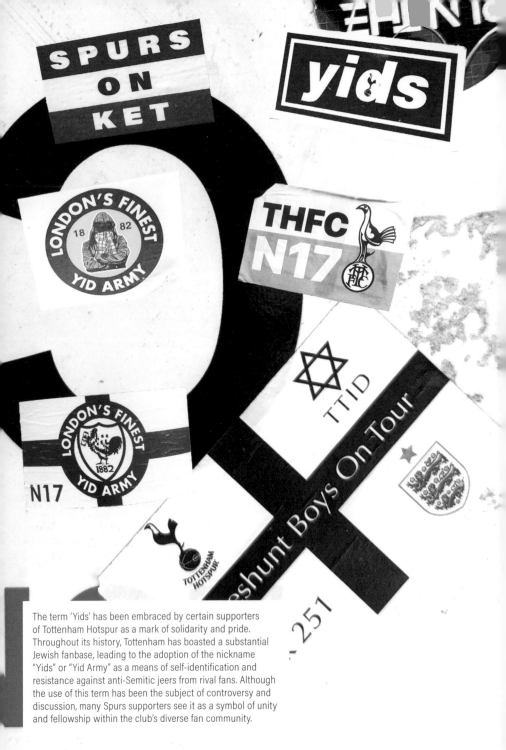

The term 'Yids' has been embraced by certain supporters of Tottenham Hotspur as a mark of solidarity and pride. Throughout its history, Tottenham has boasted a substantial Jewish fanbase, leading to the adoption of the nickname "Yids" or "Yid Army" as a means of self-identification and resistance against anti-Semitic jeers from rival fans. Although the use of this term has been the subject of controversy and discussion, many Spurs supporters see it as a symbol of unity and fellowship within the club's diverse fan community.

CAN'T SMILE
WITHOUT YOU

West Ham
Made In France
Froggy's On Tour
SINCE 2011
France

WEST HAM UNITED

THE SPORTSMAN
LORD NAPIER

JUKEBOX HAMMERS
CHAMPIONS
OF
EUROPE

SSLAZIO

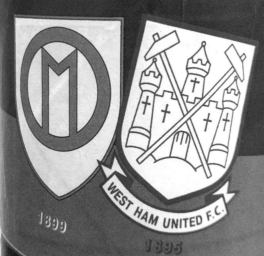

ULTRA

1899

WEST HAM UNITED F.C.

1895

CCFC

WEST LONDON HAMMERS

THE COCKNEY BOYS
LONDON'S FINEST

SAME OLD WEST HAM
TAKING THE PISS

A C
WEST HAM
RIOT CREW
A B

REM CULT

DRM

THE WOLF OF WATFORD SHITS ON LUTON

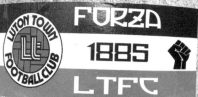

PRIDE. PASSION. BELIEF

FUCK THE F.A

ATFORD ROOKERY

8 81

IEN, NOW, FOREVER

FORZA 1885 LTFC

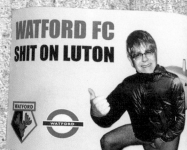

WATFORD FC SHIT ON LUTON

LUTON TOWN FC

EST 1885 HATTERS ON TOUR

HATE WATFORD

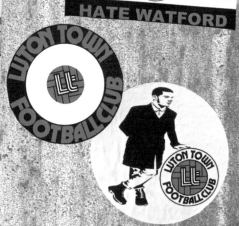

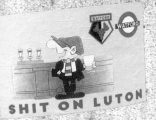

SHIT ON LUTON

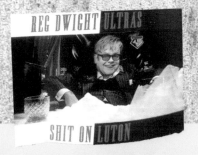

REG DWIGHT ULTRAS

SHIT ON LUTON

Sir Elton John supported Watford FC from childhood and bought the club in 1976. He stepped down as chairman of Watford in 2002, but serves as honorary life-president of the Championship club. The M1 motorway north of London connects Watford FC (The Hornets) and Luton Town (The Hatters), who have a long-standing rivalry now sometimes referred to as the M1 Derby.

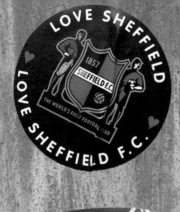

LOVE SHEFFIELD
LOVE SHEFFIELD F.C.
1857
SHEFFIELD F.C.
THE WORLD'S FIRST FOOTBALL CLUB

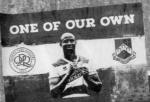

ONE OF OUR OWN

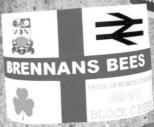

WEST HAM UNIT
POLISH HAMMERS

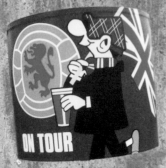

ON TOUR

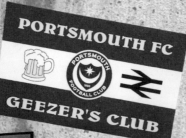

BRENNANS BEES
PRIDE OF NORTH LONDON
BLOCK C BEES

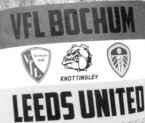

VFL BOCHUM
Bochum 1848
KNOTTINGLEY
LEEDS UNITED

PORTSMOUTH FC
PORTSMOUTH
FOOTBALL CLUB
GEEZER'S CLUB

BEES-ERKERS
MILLWALL
LIVING FOR THE WEEKEND

FORGET NOTHING
'ORRIBLE
FORGIVE NO-ONE

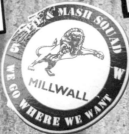

PIE & MASH SQUAD
MILLWALL
WE GO WHERE WE WANT

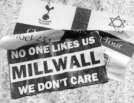

Tour
NO ONE LIKES US
MILLWALL
WE DON'T CARE

64

DERBY
LUNATIC
FRINGE

NO MATTER WHERE I ROAM

ARTE ET LABORE

I WILL RETURN TO MY ROVERS ROSE

WEST BROMWICH ALBION

TANDOORI TUESDAYS
FOR CLUB & CURRY

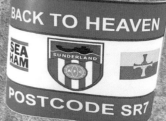

BACK TO HEAVEN

SEA HAM

SUNDERLAND

POSTCODE SR7

BIG CITY LIGHTS

DON'T BOTHER ME

Aberdare

INNESS

YOU COULD DRAG ME
TO HELL AND BACK
JUST AS LONG AS
WE'RE TOGETHER

IN YOUR MANOR
HTM

LEICESTER CITY

UNKNOWN PLEASURES

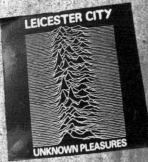

TEN STORY LOVE SONG

SMW

CONSILIO ET ANIMIS

S 04

HALLAM F.C

I BUILT THIS THING FOR YOU

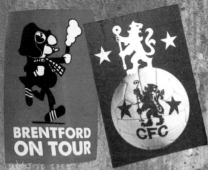

BRENTFORD
ON TOUR

CFC

THE PRIDE OF
EAST ANGLIA

ON THE BALL SINCE 1902

BARCLAY END

NORWICH

BACK OF
THE NET!

WE ARE
IPSWICH

KEEP BRITAIN TIDY

THIS IS
THE
JUAN

HULL CITY

PRIDE OF
YORKSHIRE

BRING YOUR
VODKA AND
YOUR CHARLIE

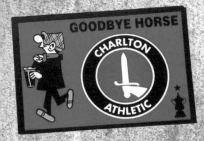

WE SHOULDN'T BE LOSING TO

TEAMS LIKE HUDDERSFIELD

GOOD AFTERNOON,
WE ARE LEEDS!
DIRTY F*CKING
LEEDS

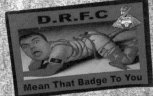

GOODBYE HORSE

CHARLTON ATHLETIC

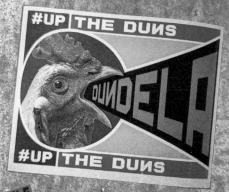

#UP THE DUNS

DUNDELA

#UP THE DUNS

D.R.F.C

Mean That Badge To You

PARTICK THISTLE
18 76
ON TOUR

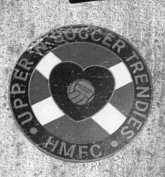

UPPER TROGGER TRENDIES
HMFC

OXFORD UNITED
18 93
THIS LOVE WILL LAST FOREVER

BOOTHAM CRESCENT
YORK CITY FC

YORK CITY FC
1822 2022
Y FRONT FANZINE

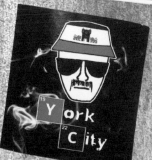

York City

UP THE ROBINS!

SELBY TOWN
100 Years

ULTRAS
AUXERRE
SOVIET TOUR

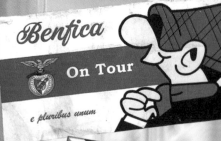

Benfica
On Tour
e pluribus unum

www.mad1902.com
MADRID
1902
BEER & RMCF

CASUALS
MALAGA C.F.
TEATINOS

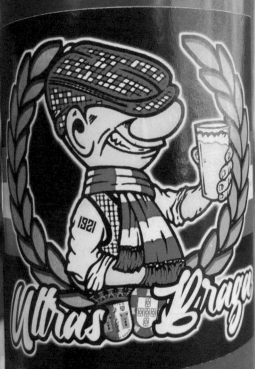

1921
Ultras Braga

ON TOUR
OLD TRAFFORD

ORGULLO DE LA CIU
ESTANDARTE
DE MADRI

A NOTE ON.... ANDY CAPP

Since his creation by cartoonist Reg Smythe in 1957, Andy Capp has evolved from a beloved British comic strip character to an international symbol embraced by football fans worldwide. With his trademark flat cap, trench coat, and penchant for pints, Andy Capp was essentially English and working class, but his appeal transcended borders.

Andy Capp's origins lie in the pages of the Daily Mirror newspaper, where he was portrayed as a lovable rogue, most at home in the pub, the betting shop, and the unemployment office. Andy resonated with an audience who saw themselves reflected in his everyday struggles. Football fans identified with his irreverent attitude and love of the game, and his influence spread to stadiums and terraces across the UK and beyond.

In the UK, Andy Capp's image adorns scarves, banners, and merchandise, with fans of clubs like Newcastle United, Sunderland, and Hartlepool United proudly displaying his likeness. His character has become synonymous with the camaraderie and banter of matchday culture, with fans embracing him as a mascot of sorts for their team.

But Andy Capp's popularity extends far beyond the British Isles. Across Europe, football supporters have adopted Andy as a symbol of their passion for the game. In Italy, fans of Serie A clubs such as Inter Milan and AC Milan can be spotted wearing Andy Capp memorabilia; while in Spain, supporters of clubs like Atletico Madrid and Sevilla FC have embraced him as representative of their working-class roots.

Teams across Eastern Europe, from CSKA Moscow to Ferencvaros, have fan groups dedicated to Andy Capp, believing he embodies the spirit of their club's working-class heritage. Andy Capp's influence is felt even as far away as South America, among supporters of clubs like Boca Juniors and River Plate in Argentina, and Flamengo and Corinthians in Brazil. Graffiti murals and street art using his image testify to the universal appeal of his character.

In conclusion, Andy Capp's journey from the pages of a British comic strip to the terraces of football stadiums around the world demonstrates his enduring popularity and cultural significance. As football continues to unite fans from diverse backgrounds and cultures, Andy Capp remains a beloved icon whose legacy transcends borders and generations.

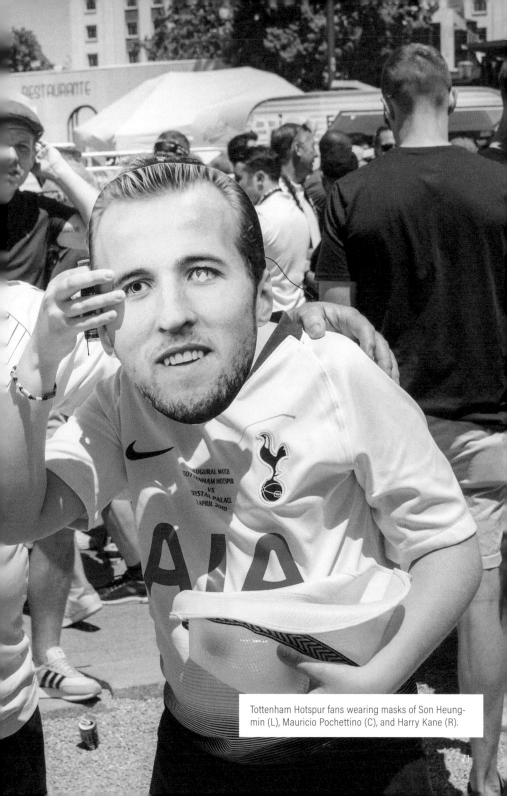

Tottenham Hotspur fans wearing masks of Son Heung-min (L), Mauricio Pochettino (C), and Harry Kane (R).

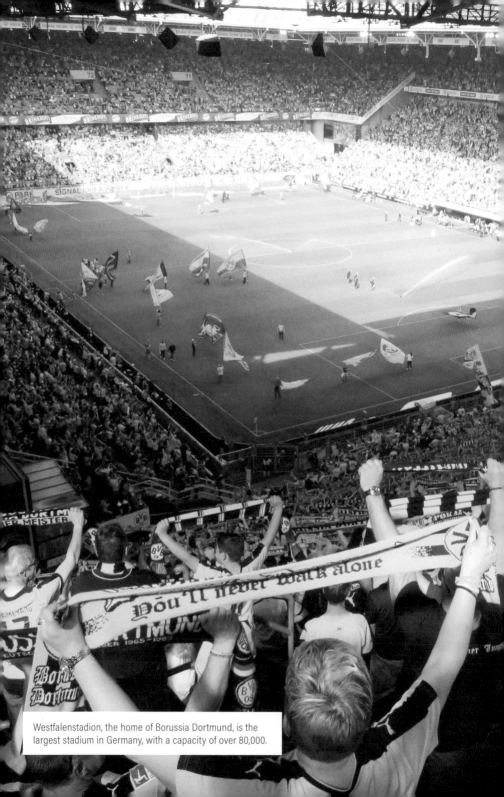

Westfalenstadion, the home of Borussia Dortmund, is the largest stadium in Germany, with a capacity of over 80,000.

WESTERN EUROPE

Ajax – 74
Anderlecht – 76
Bayer Leverkusen – 78
Bayern Munich – 80
Borussia Dortmund – 82
ADO Den Haag – 84
Borussia Mönchengladbach – 85
FC Basel – 86
First Vienna FC – 87

Feyenoord – 88
Eintracht Frankfurt – 90
FC Hansa Rostock – 94
Hertha BSC – 98
RC Lens – 99
FC Cologne – 100
Marseille – 102
FC Nantes – 104
Paris Saint-Germain – 106
PSV Eindhoven – 108

SK Rapid Wien – 110
Sturm Graz – 111
FC St. Pauli – 112
Union Berlin – 118
Union Saint-Gilloise – 122
VfB Stuttgart – 124
SV Werder Bremen – 125
BSC Young Boys – 126
FC Zürich – 127

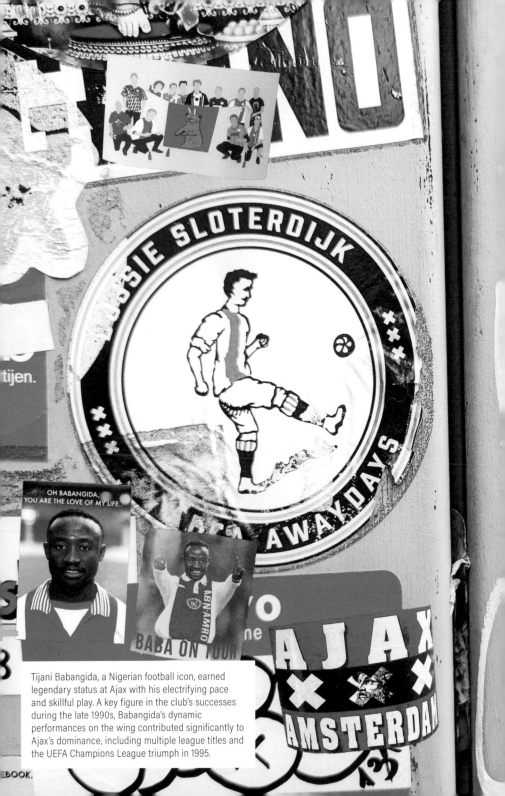

Tijani Babangida, a Nigerian football icon, earned legendary status at Ajax with his electrifying pace and skillful play. A key figure in the club's successes during the late 1990s, Babangida's dynamic performances on the wing contributed significantly to Ajax's dominance, including multiple league titles and the UEFA Champions League triumph in 1995.

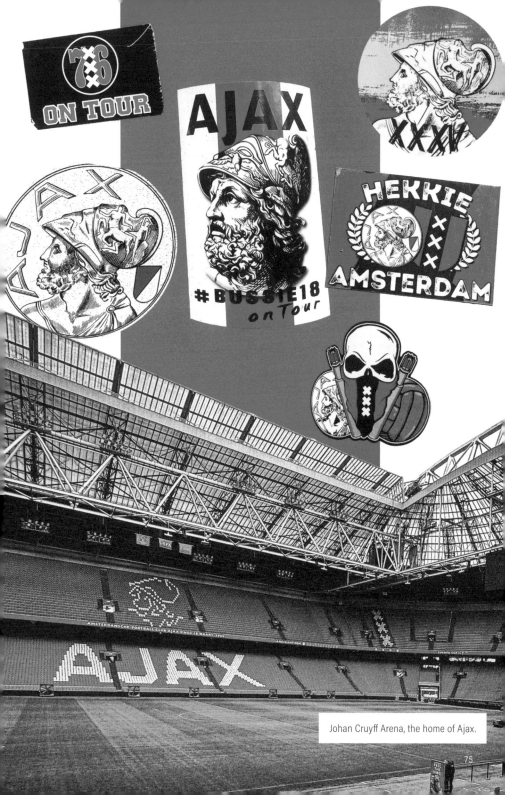

Johan Cruyff Arena, the home of Ajax.

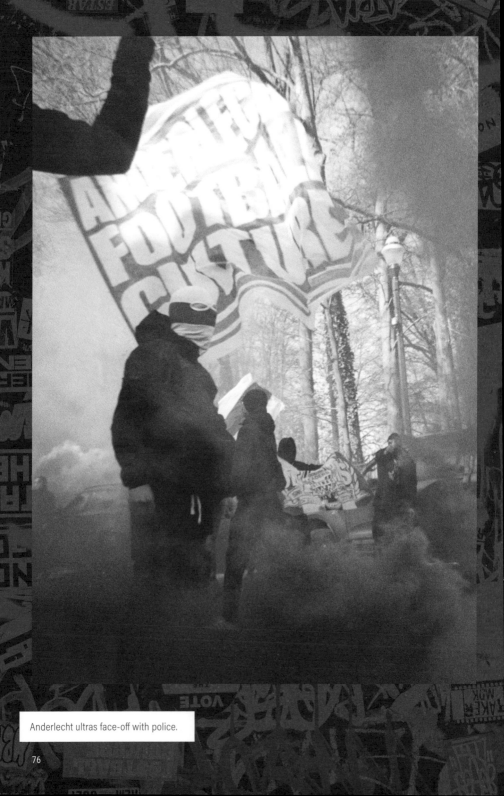

Anderlecht ultras face-off with police.

anderlecht

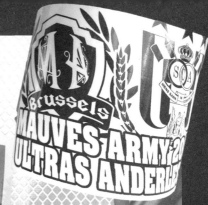

Brussels
MAUVES ARMY
ULTRAS ANDERLE...

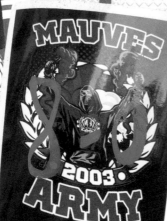

MAUVES
2003
ARMY

RSCA
FANS
AREA

ULTRAS A WAY OF LIFE

20 05
We'll never stop living this way

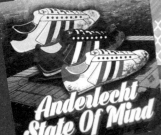

Anderlecht
State Of Mind

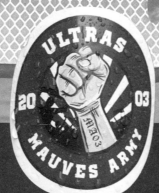

ULTRAS
20 03
MAUVES ARMY

SL
SOUTH
LEADERS
ULTRAS ANDERLECHT
2012
12

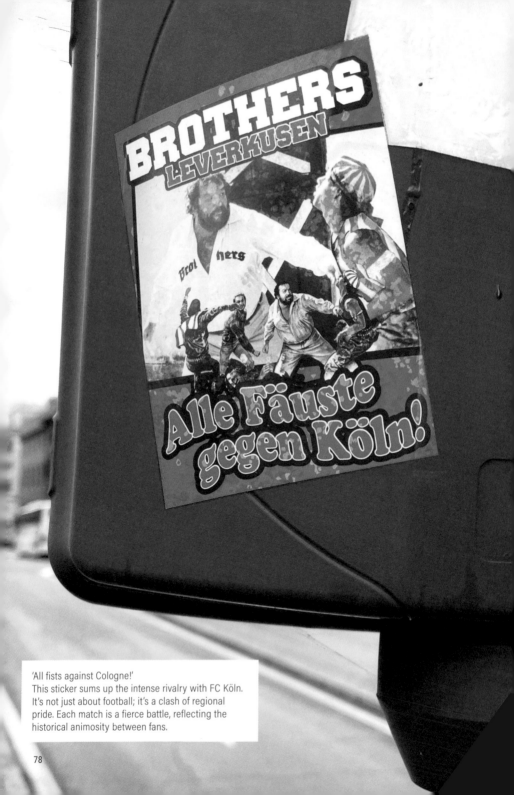

'All fists against Cologne!'
This sticker sums up the intense rivalry with FC Köln.
It's not just about football; it's a clash of regional
pride. Each match is a fierce battle, reflecting the
historical animosity between fans.

BAYER INTERNATIONAL ON TOUR

DB Der Bayer

LEVERKUSEN MITTE

SVB -1904

LEVERKUSEN 04

SPORT VEREIN
BAYER
von 1904

KAMPF VÖLLER

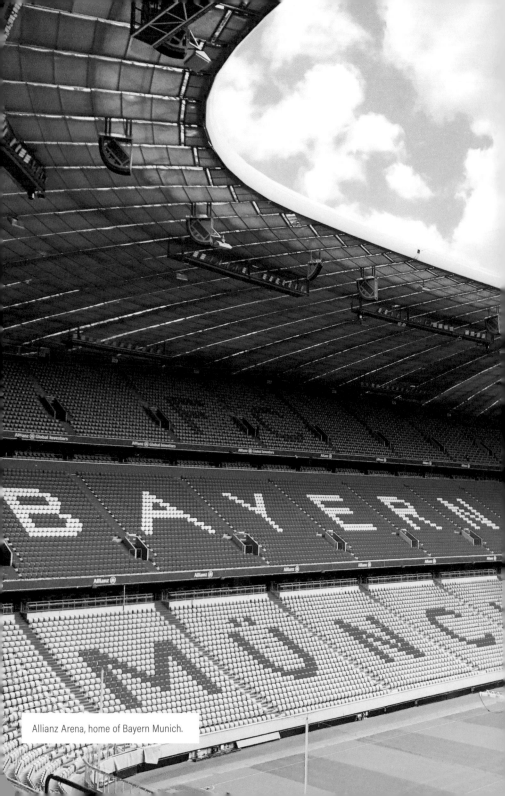

Allianz Arena, home of Bayern Munich.

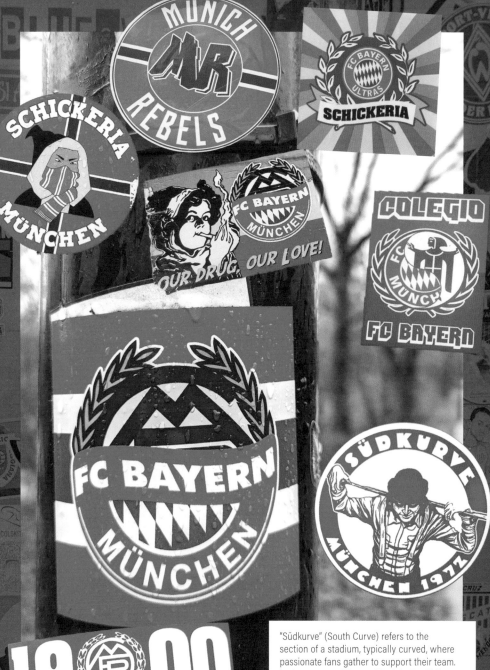

"Südkurve" (South Curve) refers to the section of a stadium, typically curved, where passionate fans gather to support their team. In the context of Bayern Munich, the Südkurve specifically denotes the southern part of the Allianz Arena, where the most fervent Bayern supporters congregate during matches.

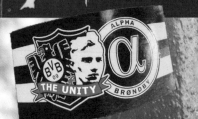

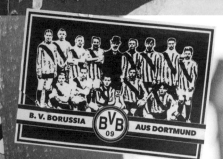

BALLSPIELVEREIN BORUSSIA

BRUSSIA!
BRUSSIA!
BRUSSIA!

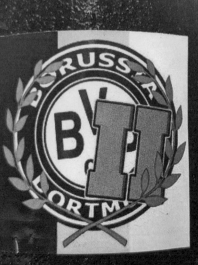

LOVE BORUSSIA
HATE FASCISM

THE UNITY
ULTRAS 2001

THE UNITY

"BOAH EY,
BOAH EY
BORUSSIA
GEH' NIE
VORBEI!"

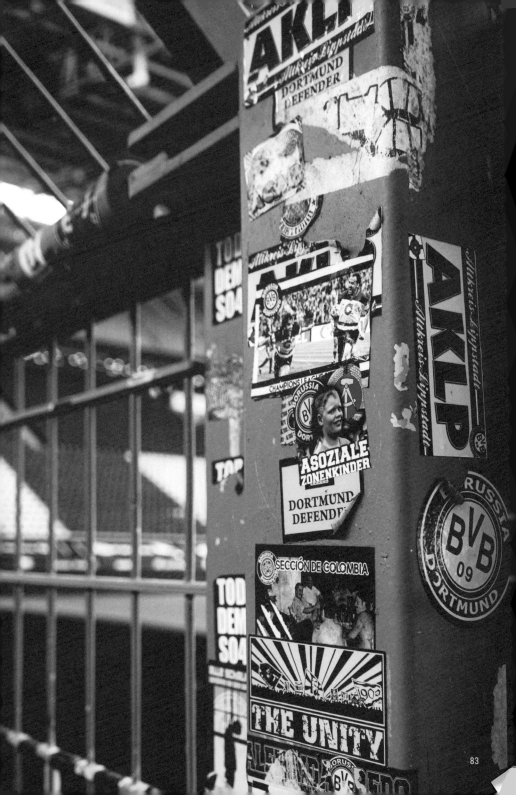

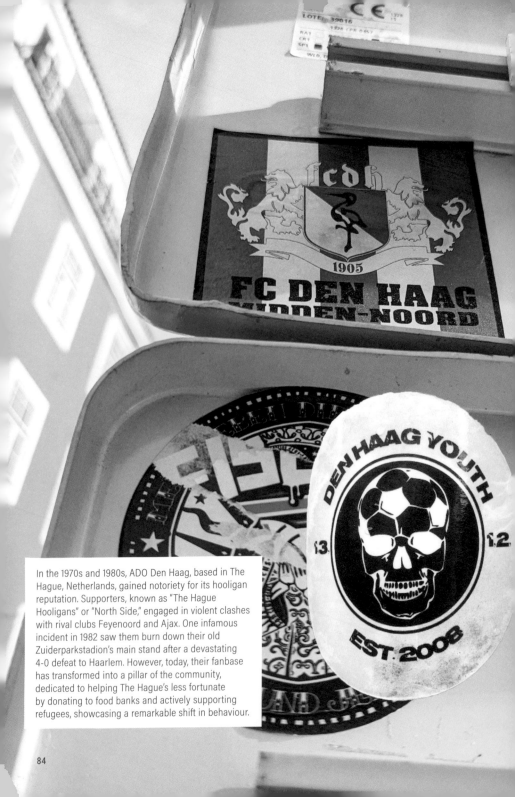

In the 1970s and 1980s, ADO Den Haag, based in The Hague, Netherlands, gained notoriety for its hooligan reputation. Supporters, known as "The Hague Hooligans" or "North Side," engaged in violent clashes with rival clubs Feyenoord and Ajax. One infamous incident in 1982 saw them burn down their old Zuiderparkstadion's main stand after a devastating 4-0 defeat to Haarlem. However, today, their fanbase has transformed into a pillar of the community, dedicated to helping The Hague's less fortunate by donating to food banks and actively supporting refugees, showcasing a remarkable shift in behaviour.

BORUSSIA
MÖNCHENGLADBACH
VFL 1900

DEUTSCHER MEISTER
1970 . 1971
1975 . 1976
1977

DFB POKALSIEGER
1960
1973
1995

UEFA-CUP SIEGER
1975 1979

F'hain

Borussen

YOU'LL NEVER WALK ALONE
LFC

19 Fußball Club Borussia M.Gladb.Eicken 00

2015 / 2016
Europatour

BORUSSIA
M-GLADBACH
ULTRAS

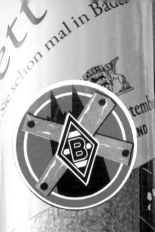

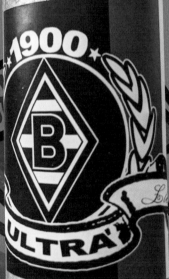
★1900★
ULTRA'

FOOTBALL INC.
FOOTBALL INC.

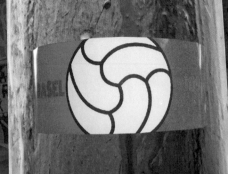

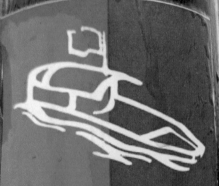

ZONA BASILEA

FÜR UNSERI
SCHÖNI STADT

MUTTENZER
KURVE
BASEL

MIR STÖHN IMMER HINTER DIR

FC BASEL

für immer

1
8
9
3

FUESSBALLCLUB
BASEL

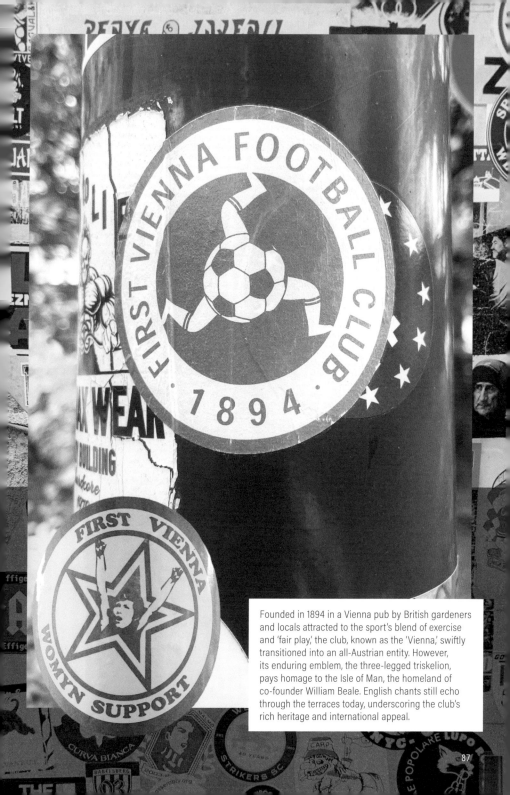

Founded in 1894 in a Vienna pub by British gardeners and locals attracted to the sport's blend of exercise and 'fair play,' the club, known as the 'Vienna,' swiftly transitioned into an all-Austrian entity. However, its enduring emblem, the three-legged triskelion, pays homage to the Isle of Man, the homeland of co-founder William Beale. English chants still echo through the terraces today, underscoring the club's rich heritage and international appeal.

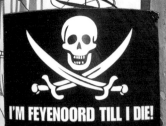

I'M FEYENOORD TILL I DIE!

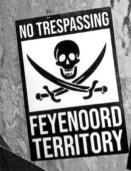

NO TRESPASSING

FEYENOORD TERRITORY

ROT TER DAM

ALL DAY

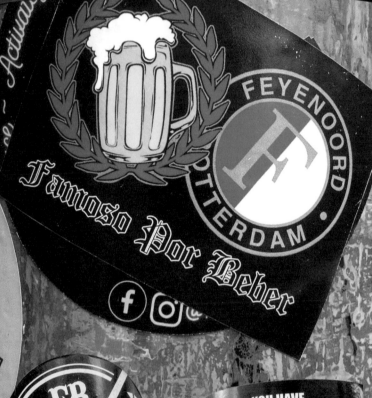

FEYENOORD ROTTERDAM

Famoso Por Beber

FR 19 08 FC

YOU HAVE BEEN VISITED BY

FEYENOORD

ROTTERDAM

FRFC 1908

divefestival.ace

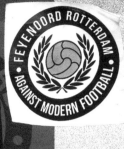
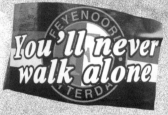
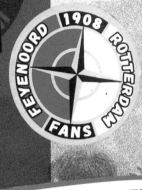
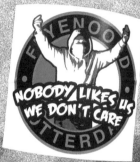

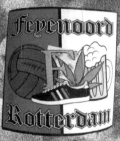

Stadion Feijenoord, affectionately nicknamed De Kuip, or 'The Tub' by its fans.

'Martial Arts & Brandy'
Frankfurt fans and Mannheim supporters go well together!

'Simple and Cool'
Bundesliga title winner and Europa Cup winning Japanese midfielder Makoto Hasebe is also the all-time leading Asian appearance maker in the Bundesliga with over 350 appearances to date.

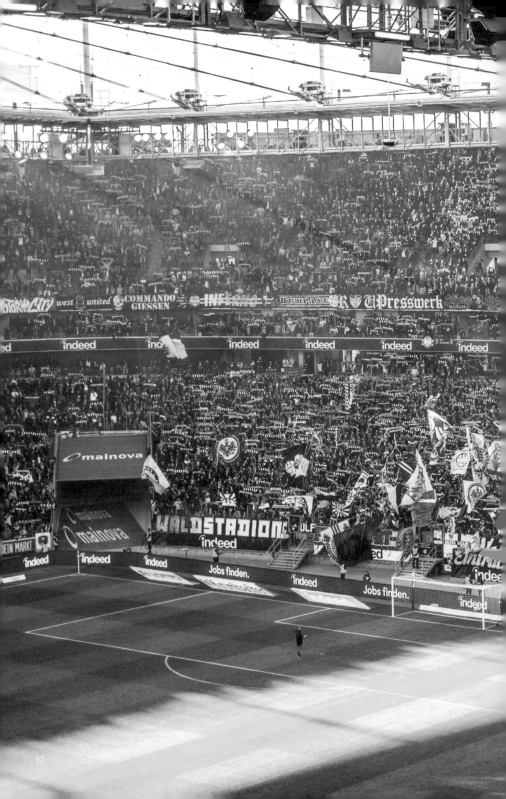

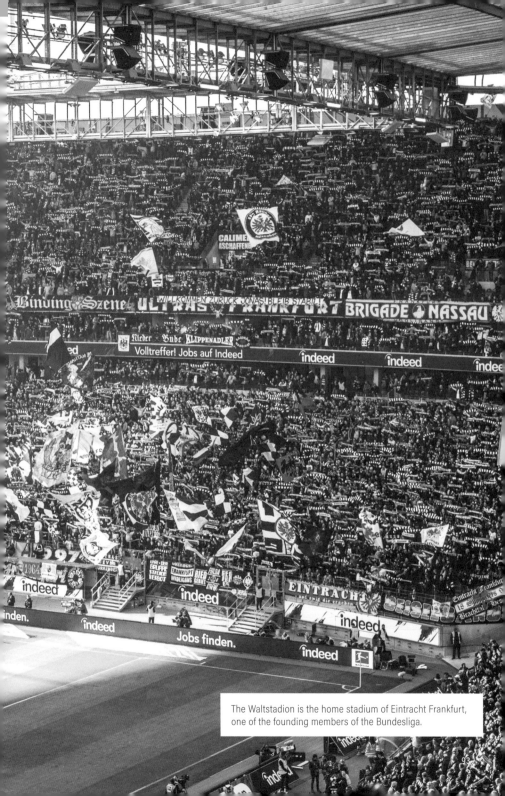

The Waltstadion is the home stadium of Eintracht Frankfurt, one of the founding members of the Bundesliga.

EINTRACHT

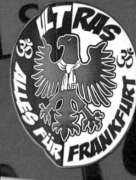

ULTRAS
ALLES FÜR FRANKFURT

EINTRACHT
FRANKFURT
ULTRAS

SUPER SGE
Der Mob hält Zeck.

ORIGINAL
Eintracht
STROH
SGE
The Spirit of Frankfurt

EINTRACHT FRANKFURT
FAN-CLUB BOCKENHEIM

EFC
Frankfurter Jungs
2005

HAUNERITTER

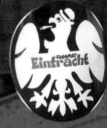

Eintracht FRANKFURT

POKAL SIEGER

EINTRACHT
1895
SIEGER TURN- U. SPORTVEREIN
TRACHT E.V. 1895

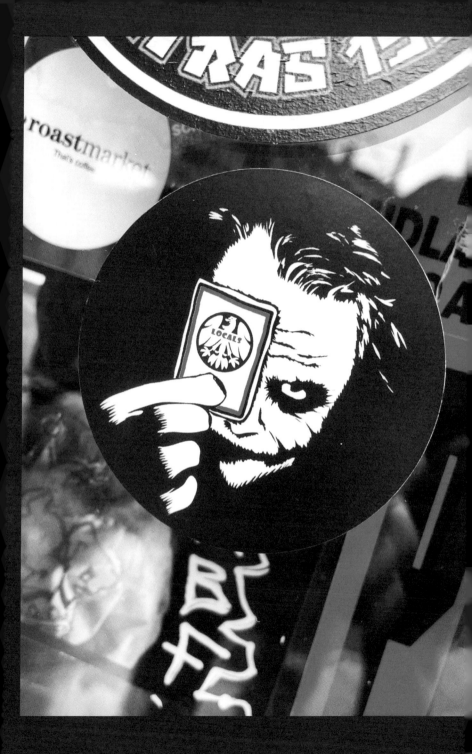

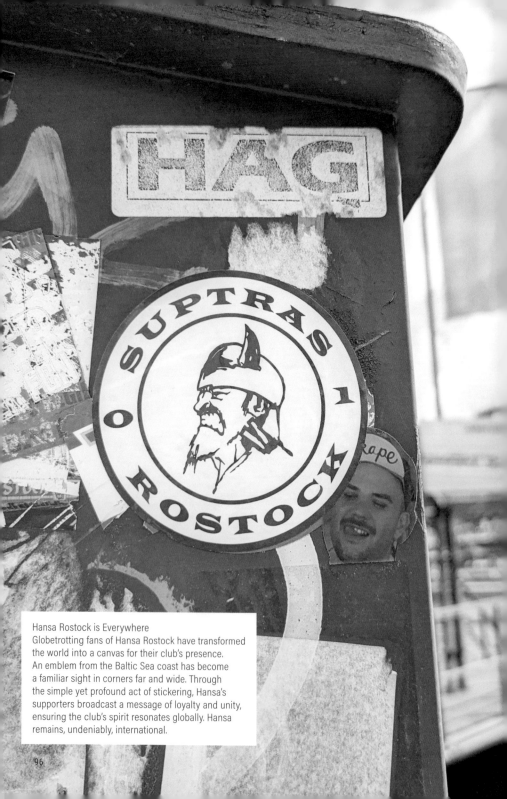

Hansa Rostock is Everywhere
Globetrotting fans of Hansa Rostock have transformed
the world into a canvas for their club's presence.
An emblem from the Baltic Sea coast has become
a familiar sight in corners far and wide. Through
the simple yet profound act of stickering, Hansa's
supporters broadcast a message of loyalty and unity,
ensuring the club's spirit resonates globally. Hansa
remains, undeniably, international.

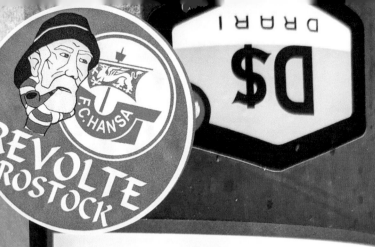
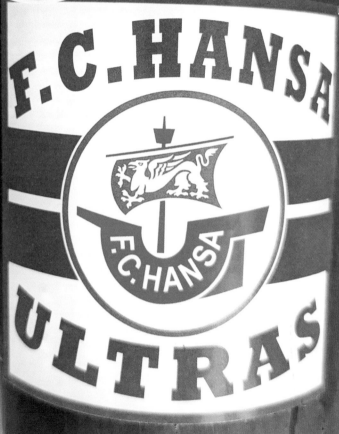

BERLIN

Hertha BSC

OLYMPIASTADION

OV

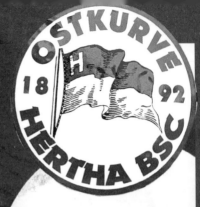

OSTKURVE

18 92

H

HERTHA BSC

...NS SIND EINE M...

Sektion
Kölsch

...ASITY

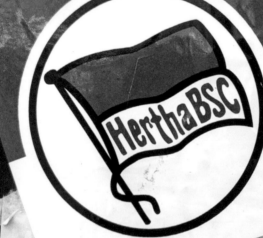

HerthaBSC

HerthaBSC

SEIT 1892

...UE HERTH
...TE RACIS...

TIGERS ULTRAS LENS 94

PARTOUT AVEC VOUS

RED TIGERS

ULTRAS LENS 1994

LENS

DEPUIS 1906

LENS FANS

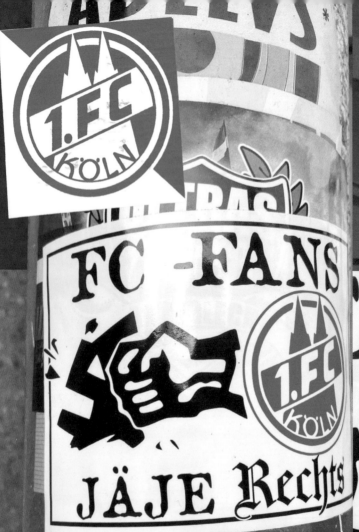

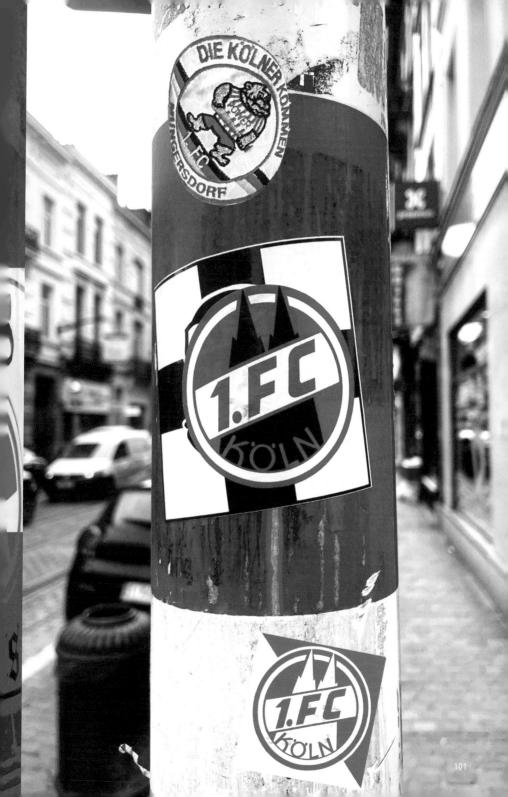

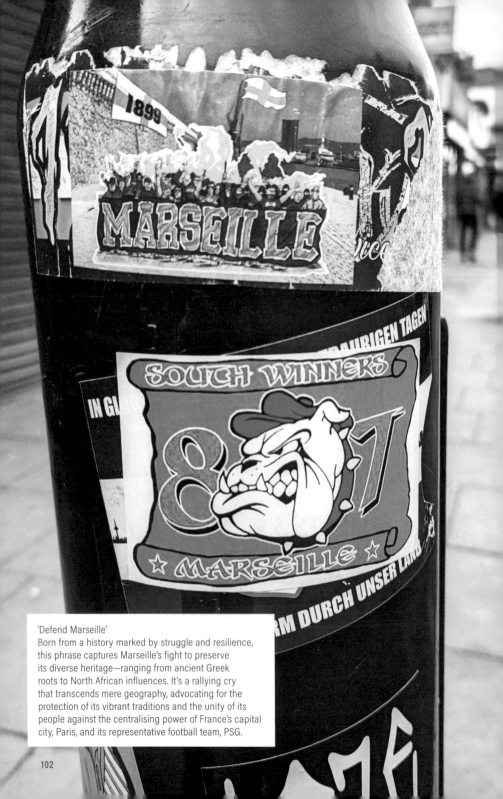

'Defend Marseille'
Born from a history marked by struggle and resilience, this phrase captures Marseille's fight to preserve its diverse heritage—ranging from ancient Greek roots to North African influences. It's a rallying cry that transcends mere geography, advocating for the protection of its vibrant traditions and the unity of its people against the centralising power of France's capital city, Paris, and its representative football team, PSG.

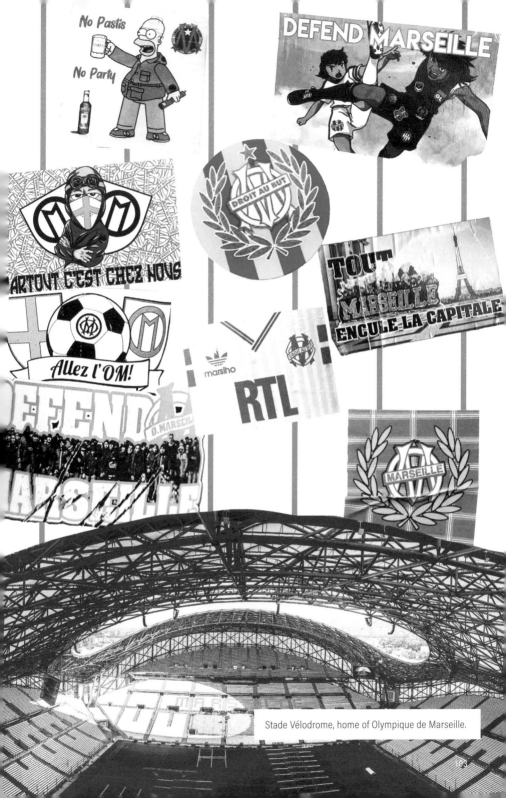

Stade Vélodrome, home of Olympique de Marseille.

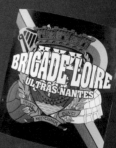

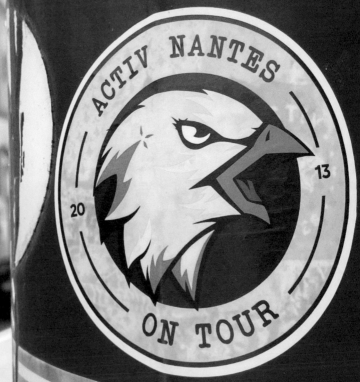

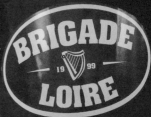

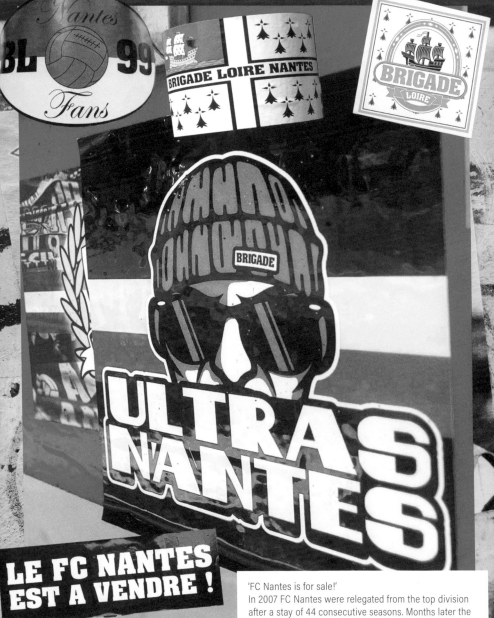

'FC Nantes is for sale!'
In 2007 FC Nantes were relegated from the top division after a stay of 44 consecutive seasons. Months later the club was sold to Polish entrepreneur Waldemar Kita for a sum reported as around €10 million. In the 17 years since his arrival, Nantes have spent only five seasons in Ligue 2, but Kita has hired and fired twenty managers and sold some top players. As is common in modern football, tensions can quickly arise between dissatisfied fans and wealthy owners.

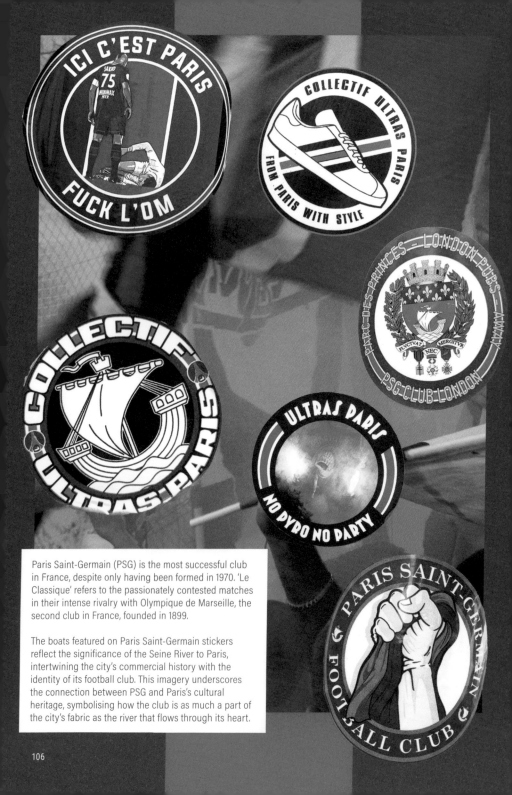

ICI C'EST PARIS
SAKO
75
NINMAX
INTER
FUCK L'OM

COLLECTIF ULTRAS PARIS
FROM PARIS WITH STYLE

PARC-DES-PRINCES — LONDON PUBS — AWAY
FLVCTVAT NEC MERGITVR
PSG-CLUB-LONDON

COLLECTIF ULTRAS PARIS

ULTRAS PARIS
NO PYRO NO PARTY

PARIS SAINT-GERMAIN
FOOTBALL CLUB

Paris Saint-Germain (PSG) is the most successful club in France, despite only having been formed in 1970. 'Le Classique' refers to the passionately contested matches in their intense rivalry with Olympique de Marseille, the second club in France, founded in 1899.

The boats featured on Paris Saint-Germain stickers reflect the significance of the Seine River to Paris, intertwining the city's commercial history with the identity of its football club. This imagery underscores the connection between PSG and Paris's cultural heritage, symbolising how the club is as much a part of the city's fabric as the river that flows through its heart.

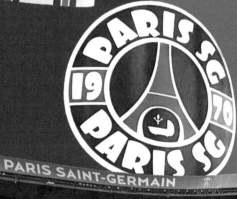

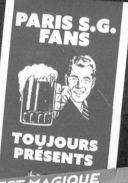

Parc des Princes, home of Paris Saint-Germain.

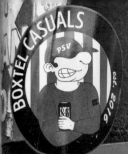

BOXTEL CASUALS
PSV

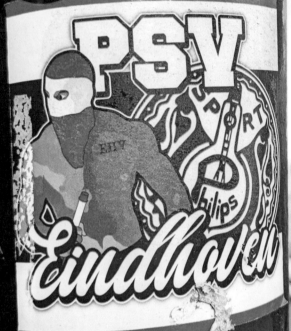

PSV
SUPORT
philips
Eindhoven
EHV

PROUD AND LOYAL
★ ★
PSV
100
GELDERLAND

TEAM DICK · EST. 2012 · VAK J

19 13
PSV Eindhoven

PHILIPS SPORT VERENIGING
PSV EHV EST. 1913
EENDRACHT MAAKT MACHT

PSV

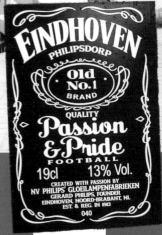

EINDHOVEN
PHILIPSDORP
Old
No.1
BRAND
QUALITY
**Passion
& Pride**
FOOTBALL
19cl 13% Vol.
CREATED WITH PASSION BY
NV PHILIPS' GLOEILAMPENFABRIEKEN
GERARD PHILIPS, FOUNDER
EINDHOVEN, NOORD-BRABANT, NL.
EST. & REG. IN 1913
040

WE ARE THE
RED-WHITE-ARMY
EINDHOVEN BOYS ARE IN TOWN

PSV
FANS UNITED

Eendracht maakt macht

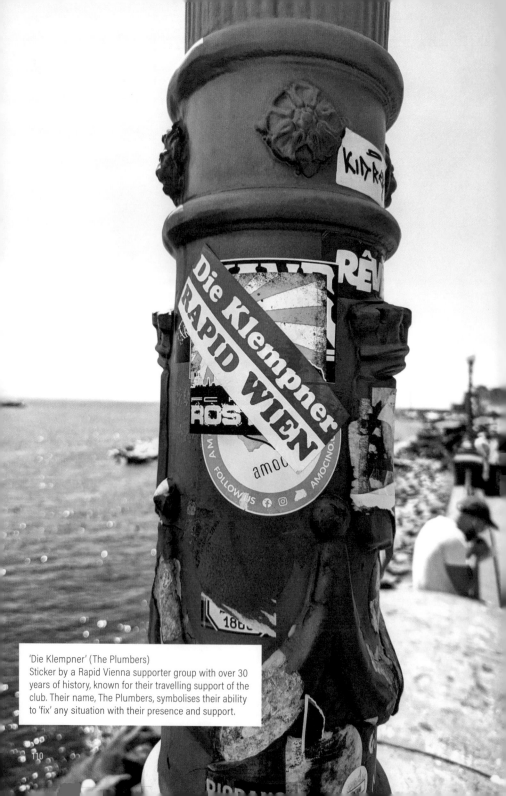

'Die Klempner' (The Plumbers)
Sticker by a Rapid Vienna supporter group with over 30 years of history, known for their travelling support of the club. Their name, The Plumbers, symbolises their ability to 'fix' any situation with their presence and support.

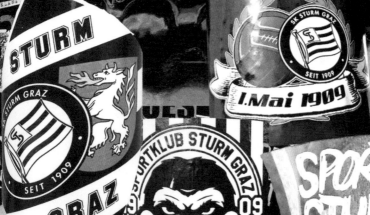

111

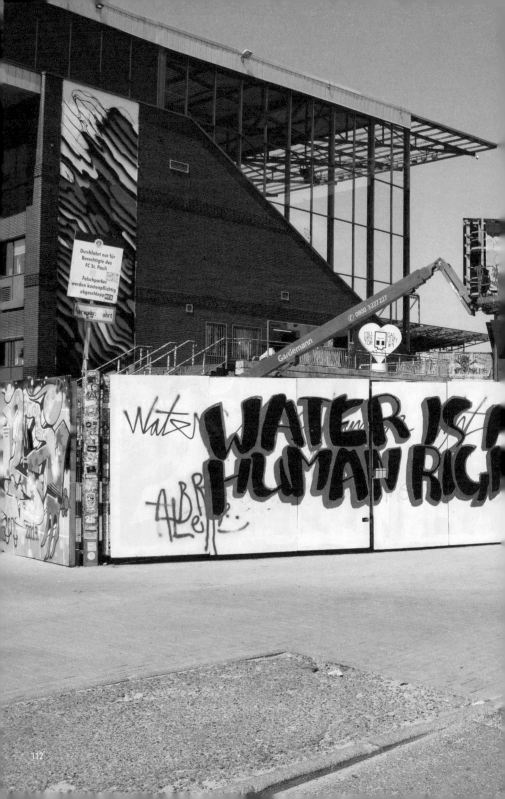

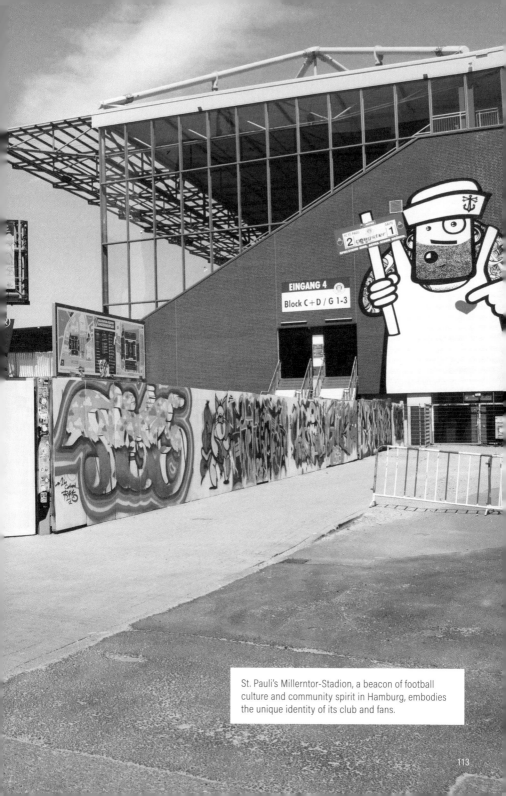

St. Pauli's Millerntor-Stadion, a beacon of football culture and community spirit in Hamburg, embodies the unique identity of its club and fans.

A sticker left behind by a St. Pauli fan in Margate, England. Many St.Pauli stickers appear all over the world created by local fan groups. Some are designed by legitimate St.Pauli supporters clubs established abroad, but others are by fans who support the principles St.Pauli stand for: left-wing politics and inclusivity striving for equality.

STPAULI.nl

piro

ESTD 1910
ST. PAULI
Millerntor

INCUL

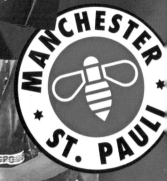

MANCHESTER
ST. PAULI

PAULI+

QUALITY
PAPERS

PAULI
PREMIUM SELECTIONS

DISPO

METT
CREW

SANKT
PAULI

2012
FC ST. PAULI
1910

METT·CREW

DISPO BOYZ
ST. PAULI

CLAUS-BUBKE-CUP
EST. 2023 – FC ST. PAULI

Live long and prosper
and follow
St. Pauli!

FC ST. PA

FC ST. PAULI
1910

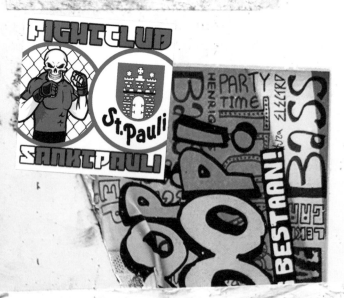

ST.PAULI-FANS

FC ST. PAULI 1910

GEGEN RECHTS!

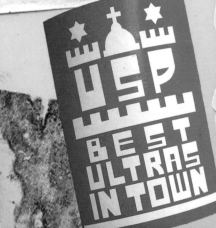

USP BEST ULTRAS IN TOWN

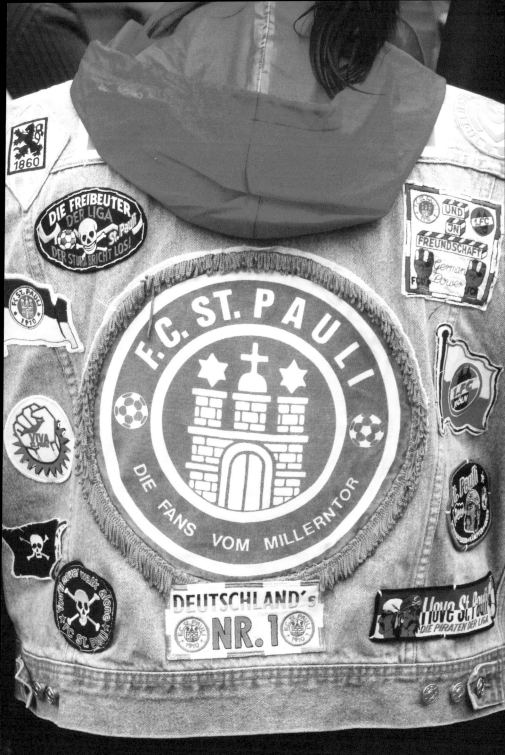

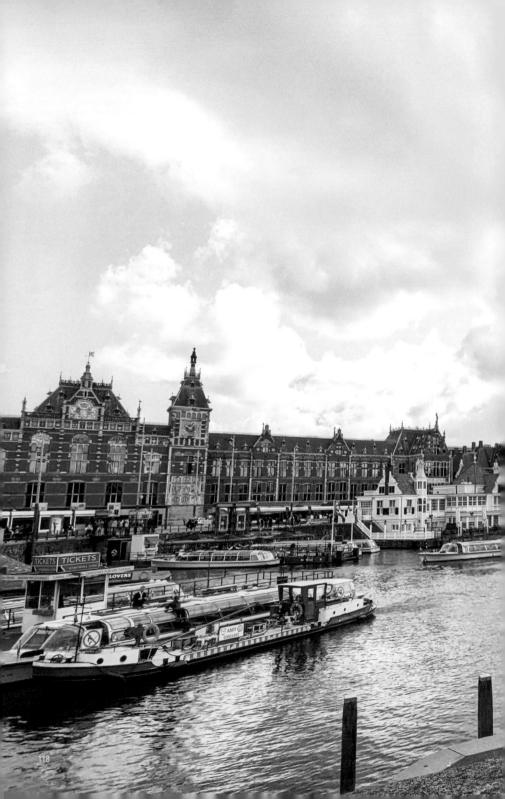

Union Berlin sticker spotted outside Amsterdam Centraal Station.

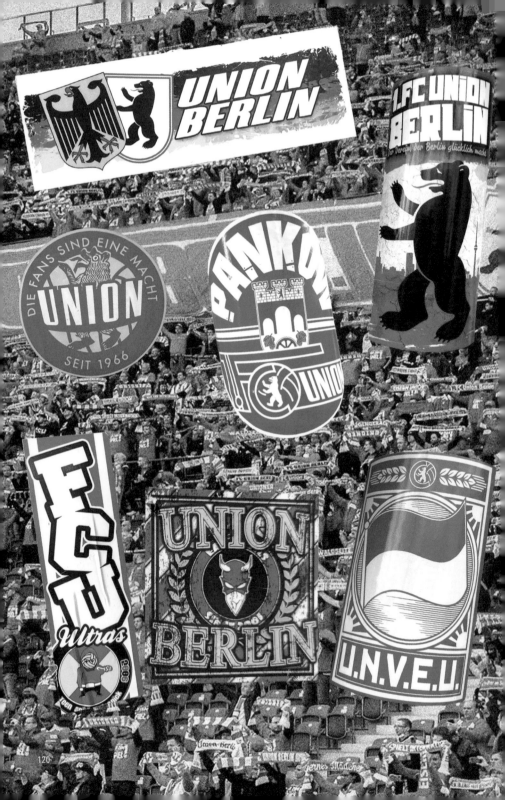

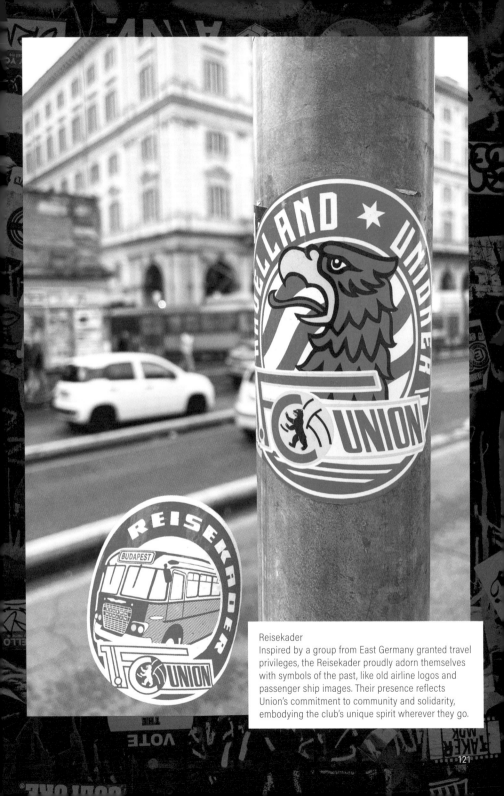

Reisekader
Inspired by a group from East Germany granted travel privileges, the Reisekader proudly adorn themselves with symbols of the past, like old airline logos and passenger ship images. Their presence reflects Union's commitment to community and solidarity, embodying the club's unique spirit wherever they go.

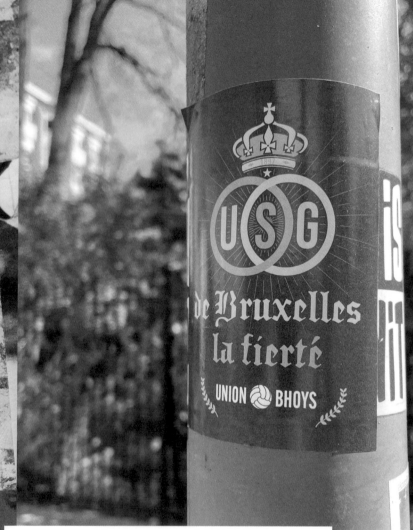

Royale Union Saint-Gilloise, fondly referred to as Union SG, boasts a passionate fanbase known as the Union Bhoys. Established in 1897, Union SG holds a storied place in the history of Belgian football. The Union Bhoys supporters group, founded in 2001, embodies the fervent spirit of the club's fans, leaving an indelible mark not only within the stadium but also on the streets of Brussels. Their stickers adorn the cityscape, showcasing the creative talents within their ranks. The Union Bhoys' designs mirror the diverse and dynamic culture of Brussels.

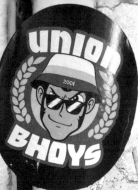

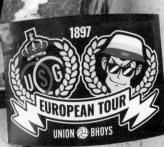

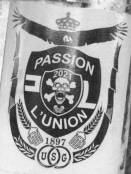

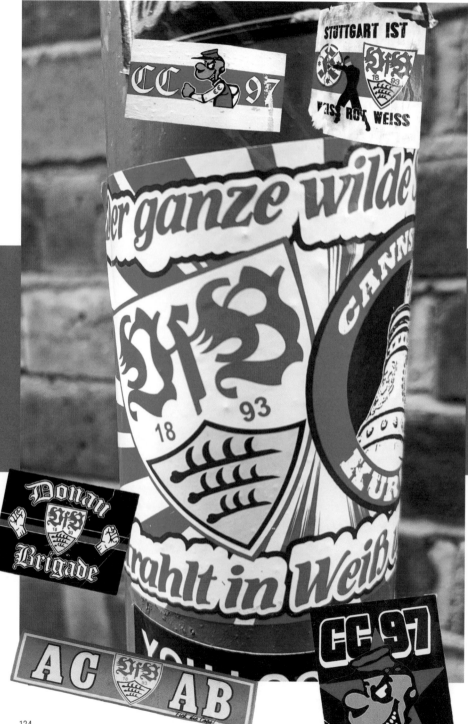

124

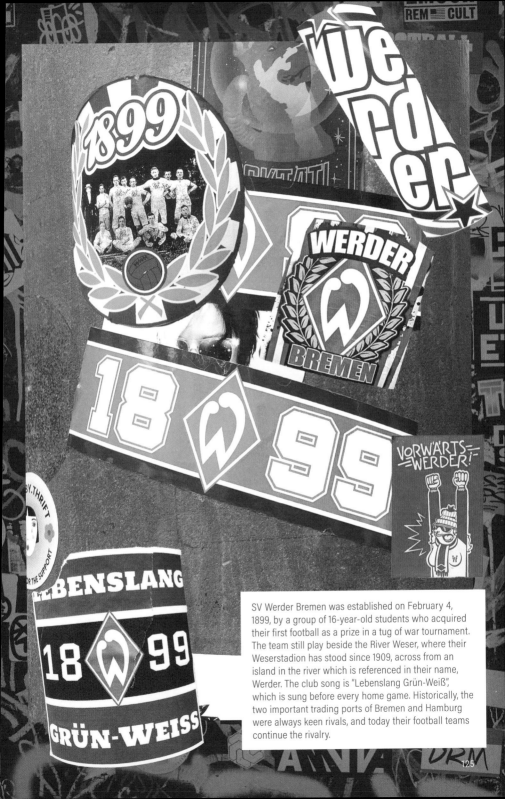

SV Werder Bremen was established on February 4, 1899, by a group of 16-year-old students who acquired their first football as a prize in a tug of war tournament. The team still play beside the River Weser, where their Weserstadion has stood since 1909, across from an island in the river which is referenced in their name, Werder. The club song is "Lebenslang Grün-Weiß", which is sung before every home game. Historically, the two important trading ports of Bremen and Hamburg were always keen rivals, and today their football teams continue the rivalry.

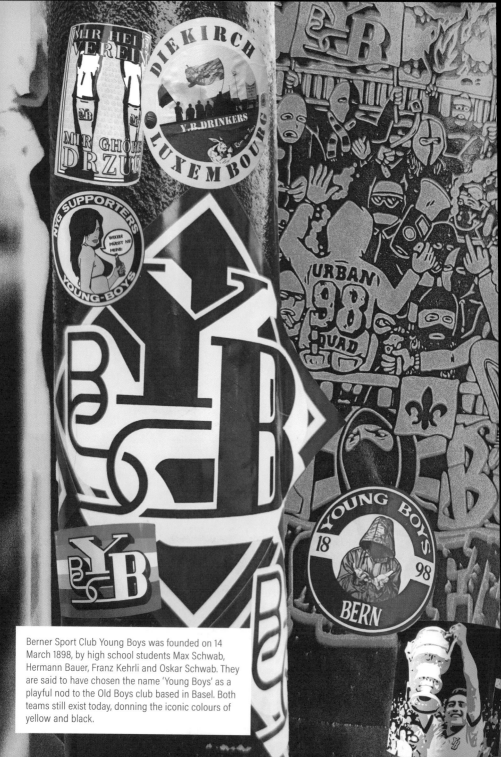

Berner Sport Club Young Boys was founded on 14 March 1898, by high school students Max Schwab, Hermann Bauer, Franz Kehrli and Oskar Schwab. They are said to have chosen the name 'Young Boys' as a playful nod to the Old Boys club based in Basel. Both teams still exist today, donning the iconic colours of yellow and black.

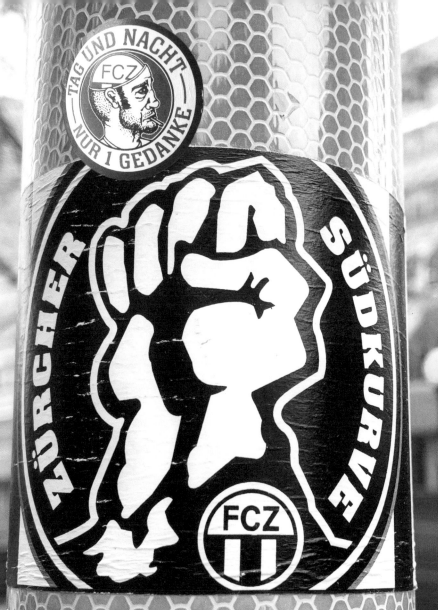

127

JEUNESSE BAD GONES

BAD GONES

AJ AUXERRE

TRIBUNE NORD SOCHAUX

ZONE ANTI RACISTE

JEUNE GARDE MONTPELLIER

25

JEUNESSE GRUPPA METZ

SOCHAUX ULTRAS

TRIBUNE NORD

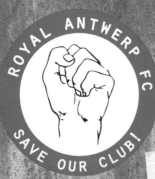

ROYAL ANTWERP FC
SAVE OUR CLUB!

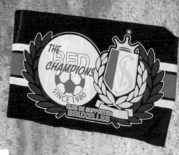

THE RED CHAMPIONS
SINCE 1980

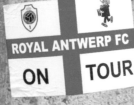

ROYAL ANTWERP FC

ON TOUR

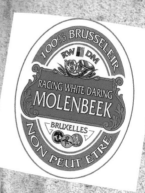

100% BRUSSELEIR
RW DM
RACING WHITE DARING
MOLENBEEK
BRUXELLES
NON PEUT ETRE

LEUVEN
ON TOUR

BRUGES CASUALS
IEPER NOORD

ALKMAAR
20 15
YOUTH

ANTI
HERACLES

HERACLE
1903

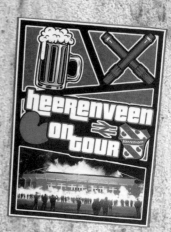

heerenveen
on tour

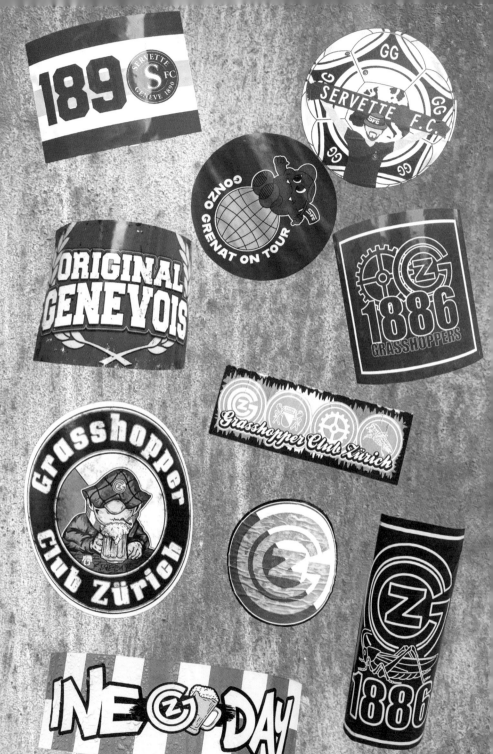

BARRIO 79 FREIBURG

VfL Bochum 1848

FÜR DIE STADT... ...UND DEN VEREIN!

SV GERMANIA
BETRIEBSSPORTGEMEINNSCHAFT

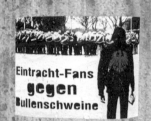

Eintracht-Fans **gegen** Bullenschweine

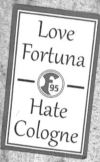

Love Fortuna — F 95 — Hate Cologne

SPORT-VEREIN NOWAWES
SN
1903

C.C. FORTUNA C.S. KÖLN
DER **SPORTCLUB** BLEIBT **ENTSPANNT**

Forza Viola

J C GANG S 04

NORD KURVE 1904

GEGEN GERADE KARLSRUHE

Karlsruher SC

JUICY CREW
FC SCHALKE 04

HAMM UNITED
FC

132

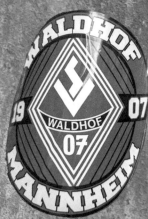

Mauve Army: Anderlecht fans energise the stadium,
proudly waving their flags.

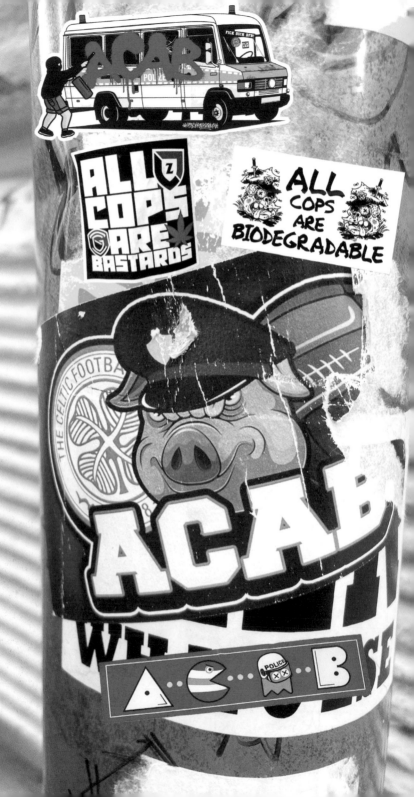

1312 ART AND STICKERS
JAMES MONTAGUE

I can't remember exactly the first time I saw it, but once I did, I saw it everywhere I went. It might have been Belgrade. Or London. Or Sarajevo. Or even Jerusalem. But in all of those places you'd find stickers, and graffiti, plastering the walls and lampposts around any stadium, with the same phrase: ACAB. 1312. Some have a more local feel. The French equivalent is "Tous les policiers sont des bastards". In Poland it is HWDP. But the sentiments were always the same. All Coppers Are Bastards.

I've been writing about football culture, politics and society for more than 15 years, and the part that always fascinated me the most were the ultras. There were a number of reasons for that. Firstly, they were completely off limits to journalists, who are scorned as part of the same establishment the police are part of. I guess you covet most what you can't have. But I was intrigued by the fact that this was also a subculture, in an age where anonymity is an impossibility, that was largely hiding in plain sight. They maintained a secrecy and detachment from the rest of the game, despite being the loudest element of it. They were also often political, on both the left and the right, and shared a deeply anti-authoritarian world view. Hence why ultras adopted ACAB, an acronym that had risen from the British Victorian criminal underworld. It was given a new life by punks, and evolved into 1312 as a way to avoid arrest once ACAB became well known to the authorities. 1312 is the aconym's alphabet code: A=1, C=3, A=1, B=2. But one aspect that rarely gets written about is why ultras are the most visible part of the game. If ultras, spread across the world and found thriving in countries as divergent as Indonesia and the United States, are arguably part of one of the world's largest youth cultures, it is also something else: one of the world's largest collective expressions of art.

Every weekend millions of people come together to create huge, elaborate choreographies. These tifos – a term that comes from the same Italian word for typhus; in effect, to be stricken by a disease – sometimes take months to plan and create. And are often displayed for only a few moments. They are beautiful murals, the best of which should be hung for prosperity. As Pepe Perretta, an Argentinian who makes perhaps the best banners in the world, told me when I met him in Buenos Aires, "The stadium is my art gallery."

Tifos always send a message. Perhaps encouragement to the team, or a threat to a rival group or, more often than not, something much more political. But they are transient, used once for a few seconds and then packed away and protected from rival groups. Stickers and graffiti are used in a more permanent way. They are still the most important method of communication, celebration and consecration in ultra culture. We live

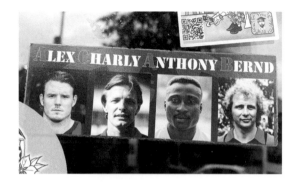

Controversial sticker depicting Eintracht Frankfurt legends Alex Meier (33), Karl-Heinz "Charly" Körbel (61), Anthony Yeboah (50), and Bernd Hölzenbein (70) arranged their initials to spell "ACAB" (All Cops Are Bastards). Created in 2016, the sticker sparked significant debate.

in an age of social media, and instant information exchange. But the sticker is still the pre-eminent form of marking a group's territory. I have thousands of them, from all around the world. Each sending a message to anyone who happens upon them. When I've travelled with ultra groups into enemy territory, we go with a stack of stickers, marking our territory as we go.

They can be blunt, or funny, or just purely offensive. In Dresden, I saw one young ultra with a stack of stickers with "FCK CPS". The German police tried to prosecute someone for wearing an ACAB t-shirt under hate speech laws. The country's top court eventually dismissed the case, but since then groups have tried other phrases to get around it just in case. It didn't work. The ultra was arrested in front of me for sticking them on a road sign. In Stockholm, in a leafy suburb right next to Hammarby's training ground, I saw a clever sticker that tried to do the same: of a taxi with the words "A Cab" underneath it. I even saw an ACAB sticker at LA FC (affixed, I should add, to a dedicated sticker wall at the back of the stadium).

In the end, I decided to write a book about ultra culture. And I had the title from the start. 1312. It was not because of a personal anti-police animus. But more practicality. Ultras

can appear uniform in terms of fashion, terminology and cultural markers, but they are a remarkably heterogeneous group that are almost impossible to define. Yet the one thing that linked them all, other than football, was their distrust, and distaste, of authority. Which is why 1312 has become such a universal symbol around football; spray painted on walls, painted on banners and stuck to lamp posts, road signs and train toilets the world over. The book came out in March 2020, the day before the COVID-19 pandemic shut the world down. I feared that the kind of collective culture of politics, art and football that ultras promoted – in the face of an increasingly atomised, online world – would not survive. But the opposite was true. It has since thrived. When the world opened back up, I moved to Istanbul. My neighbourhood at the time was next to Fenerbahce's stadium. Thousands of ultras and fans would congregate in Yoğurtçu Park to sing, light flares and drink beer before any home game. And at the end of the park, spray painted onto a concrete utility building was a large mural, surrounded by stickers, with a message I have not been able to escape: 1312.

James Montague is the author of 1312: Among the Ultras, A Journey With the World's Most Extreme Fans (Penguin).

Mauve Army: Amidst the flare's smoke, Anderlecht
fans wave their flags with pride.

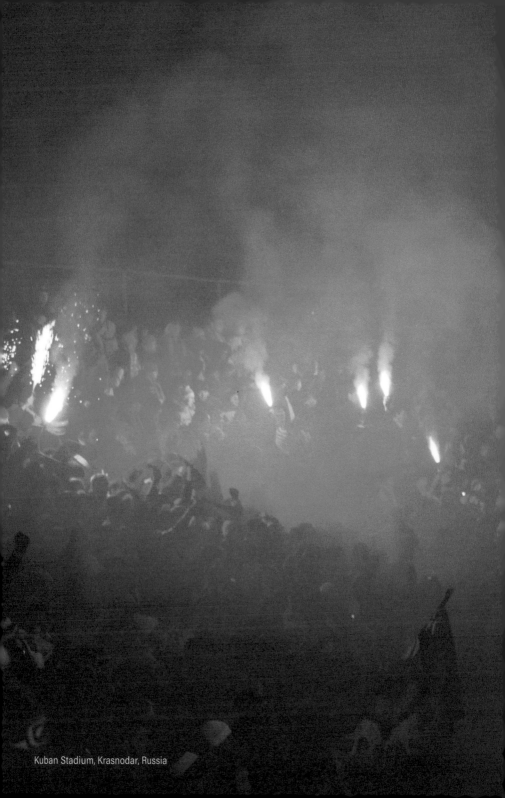

Kuban Stadium, Krasnodar, Russia

EASTERN EUROPE

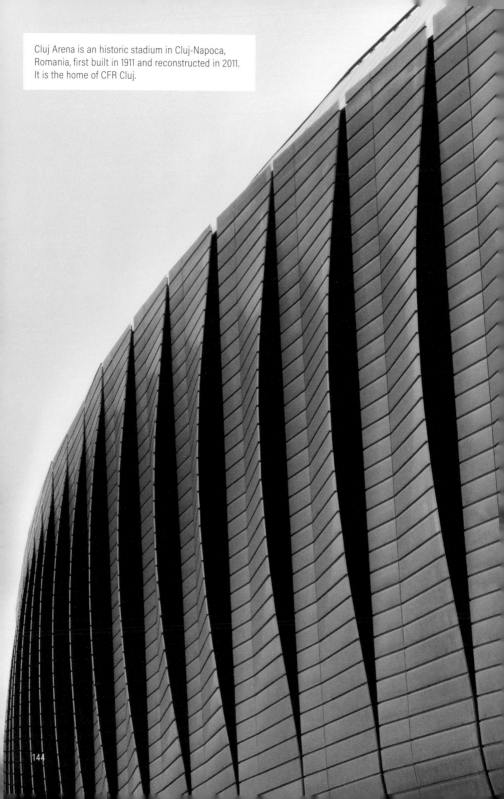

Cluj Arena is an historic stadium in Cluj-Napoca, Romania, first built in 1911 and reconstructed in 2011. It is the home of CFR Cluj.

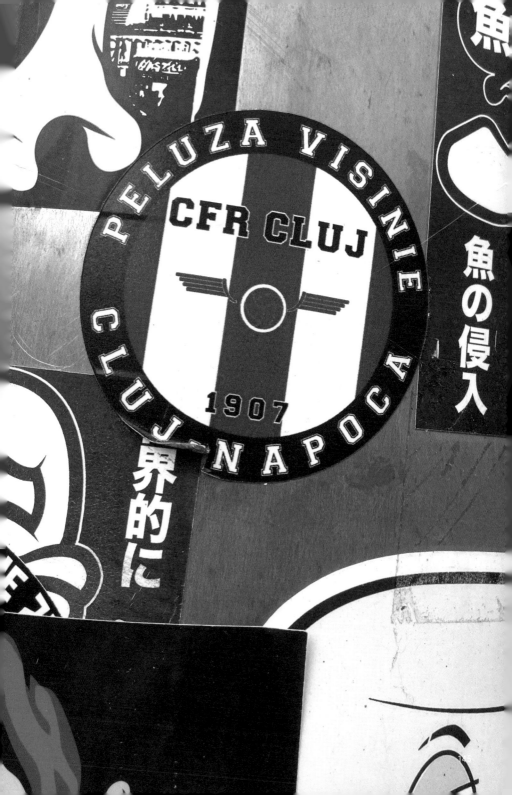

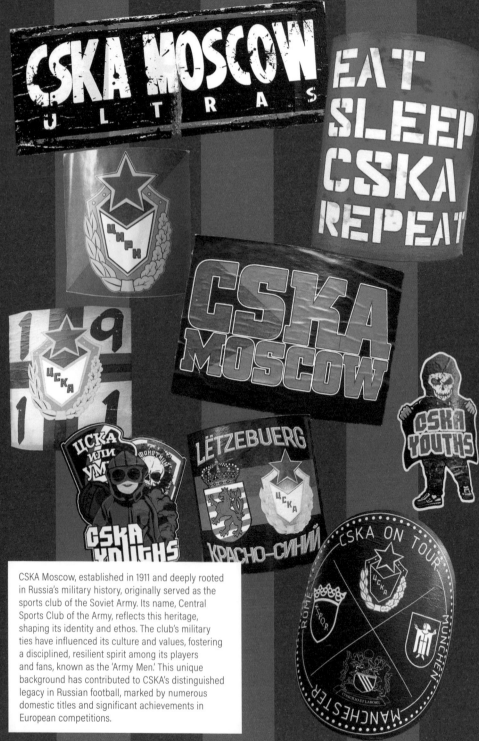

CSKA Moscow, established in 1911 and deeply rooted in Russia's military history, originally served as the sports club of the Soviet Army. Its name, Central Sports Club of the Army, reflects this heritage, shaping its identity and ethos. The club's military ties have influenced its culture and values, fostering a disciplined, resilient spirit among its players and fans, known as the 'Army Men.' This unique background has contributed to CSKA's distinguished legacy in Russian football, marked by numerous domestic titles and significant achievements in European competitions.

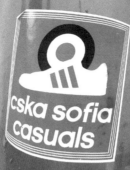

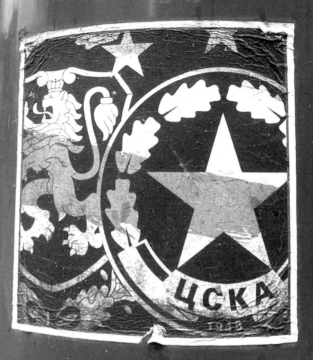

Like its Moscow counterpart, CSKA Sofia was originally founded, in 1948, as the sports club for the Bulgarian army. There is a close rivalry with their nearest neighbours, Levski Sophia.

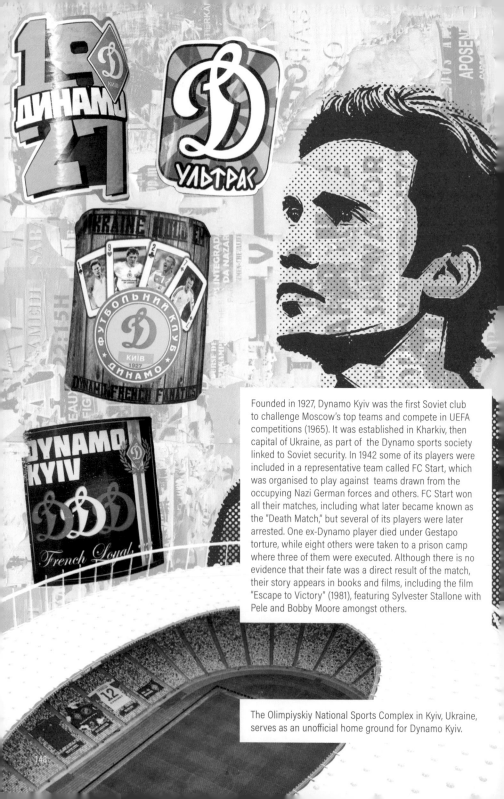

Founded in 1927, Dynamo Kyiv was the first Soviet club to challenge Moscow's top teams and compete in UEFA competitions (1965). It was established in Kharkiv, then capital of Ukraine, as part of the Dynamo sports society linked to Soviet security. In 1942 some of its players were included in a representative team called FC Start, which was organised to play against teams drawn from the occupying Nazi German forces and others. FC Start won all their matches, including what later became known as the "Death Match," but several of its players were later arrested. One ex-Dynamo player died under Gestapo torture, while eight others were taken to a prison camp where three of them were executed. Although there is no evidence that their fate was a direct result of the match, their story appears in books and films, including the film "Escape to Victory" (1981), featuring Sylvester Stallone with Pele and Bobby Moore amongst others.

The Olimpiyskiy National Sports Complex in Kyiv, Ukraine, serves as an unofficial home ground for Dynamo Kyiv.

dinamo

ZA DINAMO
DO GROBA

TI SI
MENI
SVE
d

DINAMO
ZAGREB

END SIEG

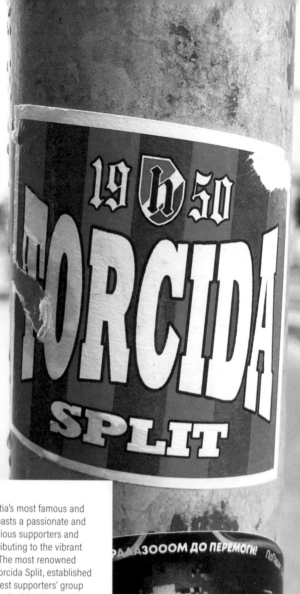

Hajduk Split, one of Croatia's most famous and historic football clubs, boasts a passionate and diverse fan base with various supporters and ultras groups, each contributing to the vibrant culture around the club. The most renowned among these groups is Torcida Split, established in 1950, making it the oldest supporters' group in Europe. Torcida was inspired by the Brazilian supporters during the 1950 FIFA World Cup, and since then, it has grown into a symbol of unwavering support for Hajduk Split, embodying the spirit and resilience of the club and its fans. Over the years, other groups have also emerged, contributing to the rich tapestry of Hajduk's supporter culture. While Torcida dominates in numbers and influence, these additional groups enrich the match-day atmosphere with their own unique chants, flags, and displays.

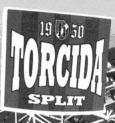

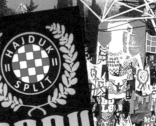

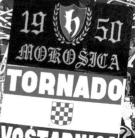

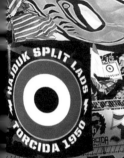

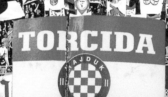

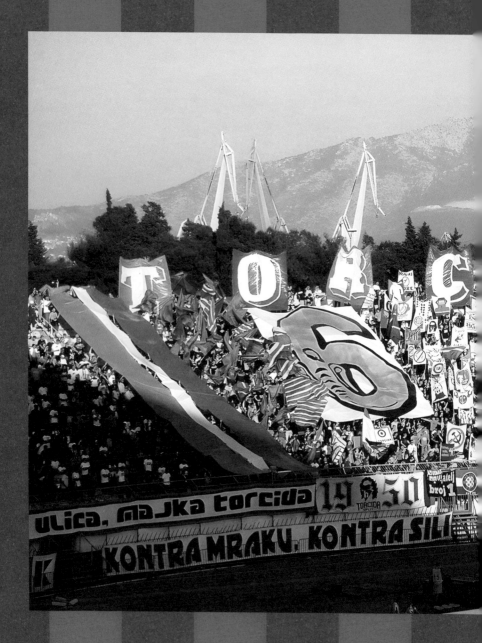

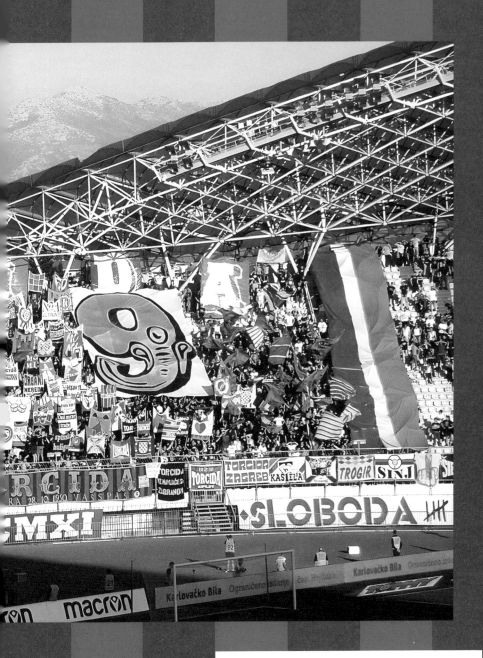

During a league match at Poljud Stadium on October 26, 2019, Torcida Hajduk celebrates its 69th anniversary.

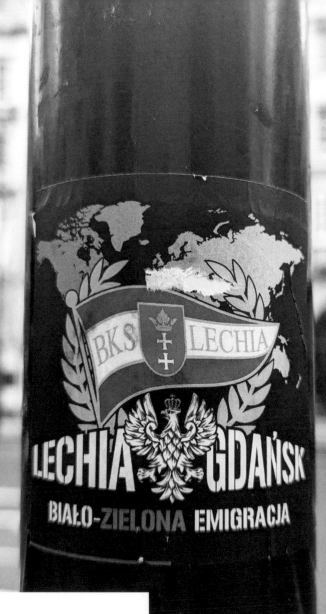

Lechia Gdańsk
The club has been a symbol of resilience and pride
since 1945 and was a part of the Solidarity struggle
against Communism during the 1980s. Lech Walesa,
the first elected President of Poland, is a fan, along
with the Polish prime minister, Donald Tusk. It is
celebrated for its fierce Tricity Derby, passionate
'Lions of the North' fans, and the iconic Stadion
Energa Gdańsk, embodying the spirit of Gdańsk
through football and community.

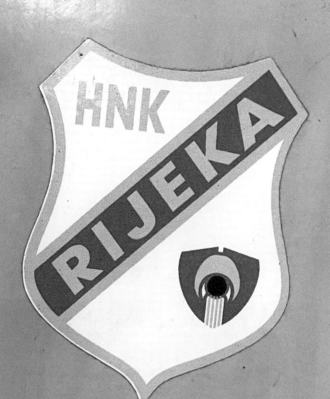

HNK Rijeka
Founded in 1946, has established itself as a stalwart of Croatian football, boasting a rich history of domestic success and passionate support, particularly from its fervent fan group, Armada Rijeka. The Adriatic Derby between HNK Rijeka and Hajduk Split stands as one of Croatian football's most intense rivalries, showcasing a deep-seated contest for supremacy that brings to life the spirited history and regional pride of the country's coastal powerhouses.

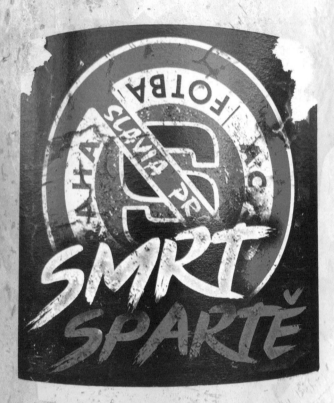

'Death of Sparta'
A sticker left behind by Slavia Praha fans symbolises the
intense rivalry with Sparta, revealing the deep-seated
competitive spirit that divides Prague's football scene.
As two of the city's most prominent teams, their clashes
are more than just games, they're historic battles for
supremacy and local bragging rights.

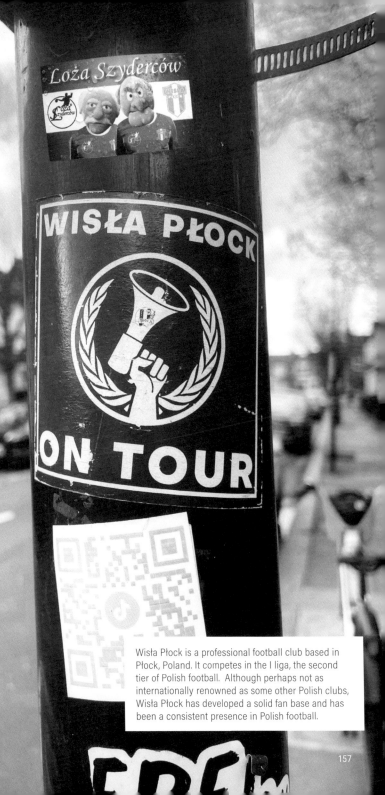

Wisła Płock is a professional football club based in Płock, Poland. It competes in the I liga, the second tier of Polish football. Although perhaps not as internationally renowned as some other Polish clubs, Wisła Płock has developed a solid fan base and has been a consistent presence in Polish football.

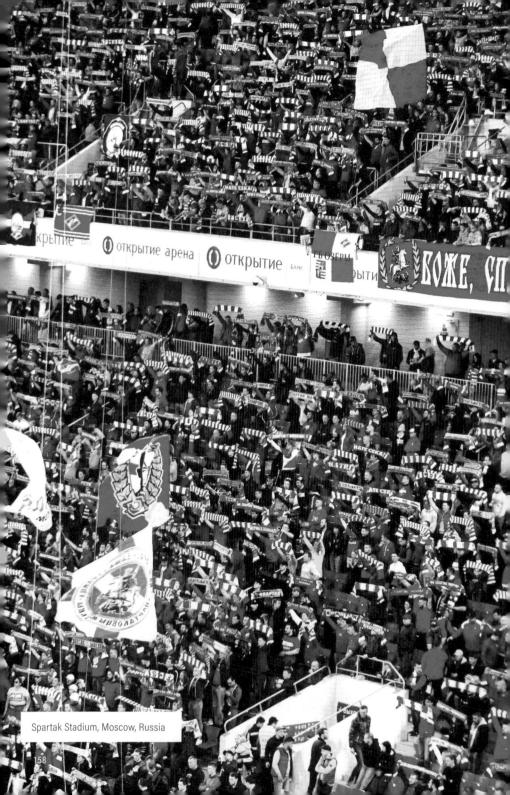

Spartak Stadium, Moscow, Russia

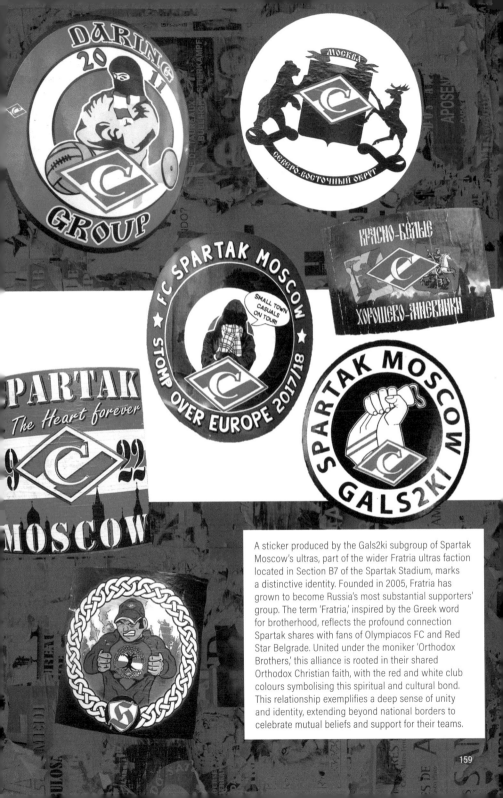

A sticker produced by the Gals2ki subgroup of Spartak Moscow's ultras, part of the wider Fratria ultras faction located in Section B7 of the Spartak Stadium, marks a distinctive identity. Founded in 2005, Fratria has grown to become Russia's most substantial supporters' group. The term 'Fratria,' inspired by the Greek word for brotherhood, reflects the profound connection Spartak shares with fans of Olympiacos FC and Red Star Belgrade. United under the moniker 'Orthodox Brothers,' this alliance is rooted in their shared Orthodox Christian faith, with the red and white club colours symbolising this spiritual and cultural bond. This relationship exemplifies a deep sense of unity and identity, extending beyond national borders to celebrate mutual beliefs and support for their teams.

KS TARNOVIA
TARNOVIA
Na Wakacjach

ŚLĄSK WROCŁAW
TAK SIĘ ZABAWIA
SZLACHTA Z WROCŁAWIA

LEGIJNE WAKACJE

PARTIZAN
REBELGRADE

FC UNIVERSITATEA
CRAIOVA

STAL SANOK
STAL
Na każdym kroku w tym mieście

I PREDICT A RIOT

FK SARAJEVO
1946

K.S. RUCH
CHORZÓW

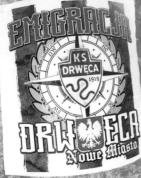

EMIGRACJA
KS DRWĘCA
1919
DRWĘCA
Nowe Miasto

POGOŃ
ULTRAS
SZCZECIN

Naftciarze
WISŁA
On Tour

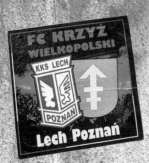

TORNADO

VOŠTARNICA

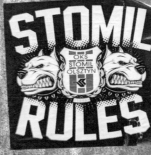

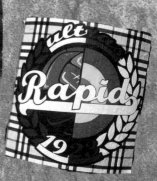

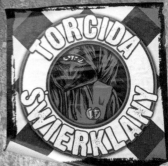

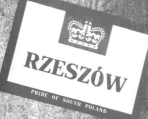

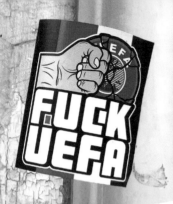

FUCK UEFA

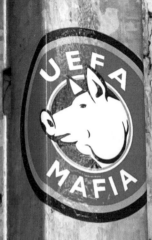

UEFA MAFIA

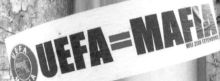

UEFA = MAFIA

UEFA MAFIA
STICKERSGRAFIK

LOVE CITY
18 94
HATE UEFA

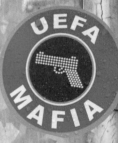

UEFA MAFIA

F*CK UEFA & THEIR
UEFA MAFIA
CORRUPT CARTEL

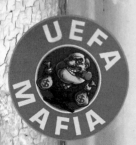

UEFA MAFIA

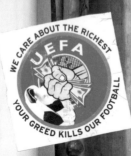

WE CARE ABOUT THE RICHEST
UEFA
YOUR GREED KILLS OUR FOOTBALL

F*CK UEFA &
THEIR CORRUPT CARTEL
WE ARE CITY
SuPeR CITY!
UEFA MAFIA

REBEL KICKS:
FANS VS UEFA'S FOOTBALL EMPIRE

In recent times, an increasing number of football enthusiasts have voiced their dissatisfaction with UEFA and the evolving landscape of the sport, notably through anti-UEFA stickers and outspoken protests. This movement mirrors a wider disillusionment with the sport's commercialisation, perceived inequalities and opaque practices.

Central to these complaints is the belief that modern football is veering towards excessive commercialism. Fans argue that clubs, with UEFA's tacit approval, are placing profits above the sport's heritage and principles. The Financial Fair Play regulations, intended to maintain financial equilibrium among clubs, are criticised for benefiting the affluent at the expense of competitive balance.

Soaring ticket prices further estrange supporters, rendering live matches unaffordable for many. Despite being the sport's backbone, regular fans often feel sidelined in favour of business interests, highlighting a broader issue with the sport's commercial and ownership models that many believe compromise its authenticity.

Additionally, there's a call for more transparency in UEFA's operations, particularly regarding club licensing and disciplinary measures. High-profile corruption cases, like the 2015 FIFA scandal, have only fueled distrust and scepticism among the fanbase.

The growing divide between the football elite and smaller, community-centric clubs amplifies feelings of injustice. Supporters are clamouring for reforms to ensure financial fairness and bolster grassroots football, stressing the need to keep the sport open and inclusive.

In reaction, fans are mobilising. The spread of anti-UEFA stickers and protest movements are not just symbols of dissatisfaction; they are demands for accountability, integrity, and a re-emphasis on football's communal roots. As these dissenting voices become more pronounced, they underscore a collective yearning for a return to the sport's fundamental values.

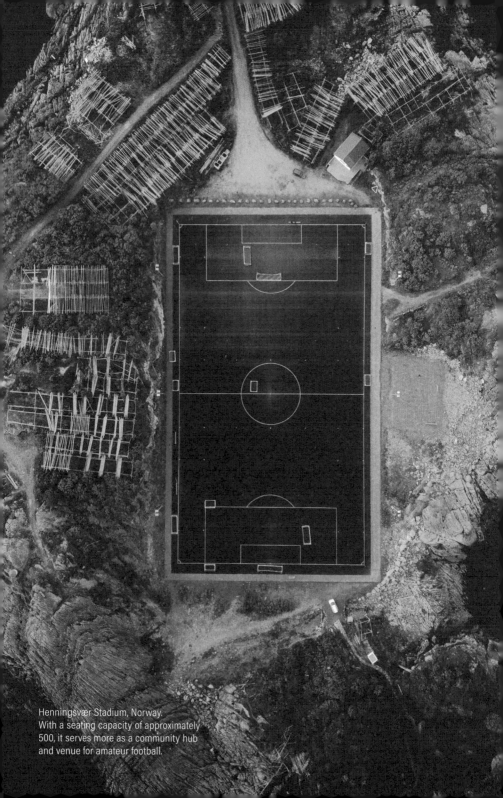

Henningsvær Stadium, Norway.
With a seating capacity of approximately
500, it serves more as a community hub
and venue for amateur football.

NORTHERN EUROPE

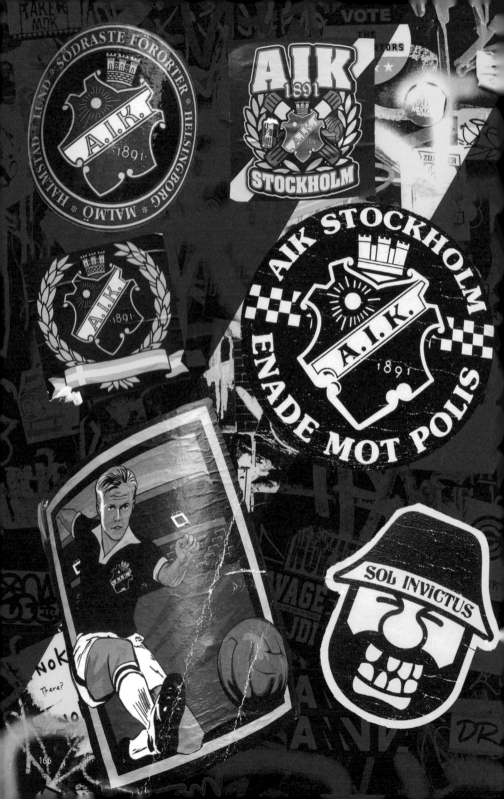

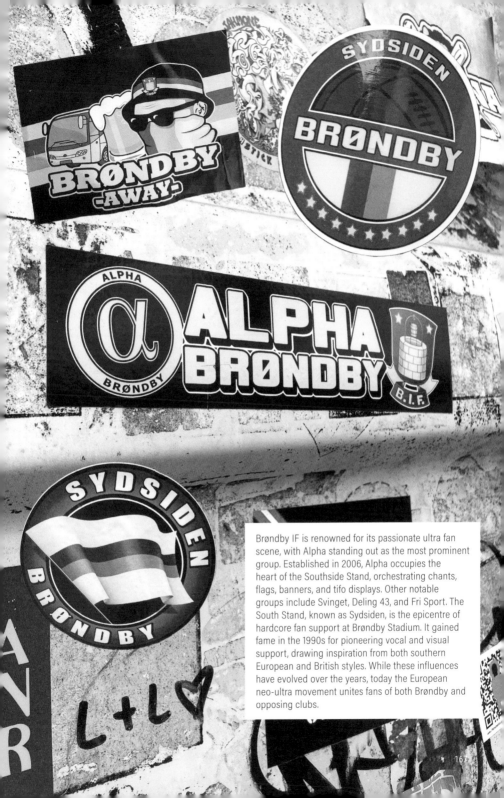

Brøndby IF is renowned for its passionate ultra fan scene, with Alpha standing out as the most prominent group. Established in 2006, Alpha occupies the heart of the Southside Stand, orchestrating chants, flags, banners, and tifo displays. Other notable groups include Svinget, Deling 43, and Fri Sport. The South Stand, known as Sydsiden, is the epicentre of hardcore fan support at Brøndby Stadium. It gained fame in the 1990s for pioneering vocal and visual support, drawing inspiration from both southern European and British styles. While these influences have evolved over the years, today the European neo-ultra movement unites fans of both Brøndby and opposing clubs.

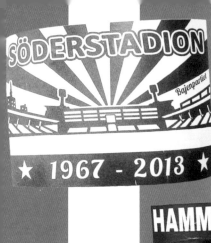

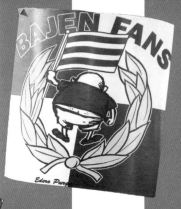

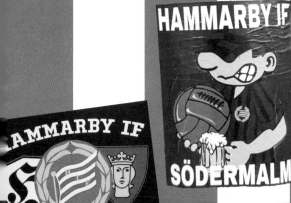

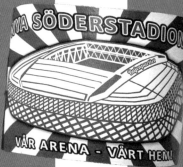

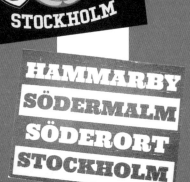

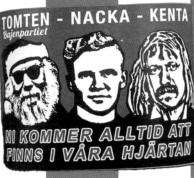

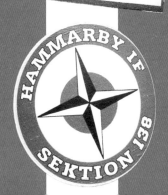

Johan 'Tomten' Johansson, Karl Lennart 'Nacka' Skoglund, and Lars Kenneth 'Kenta' Ohlsson are key figures in Hammarby Fotboll's history, each leaving a distinct mark on the club. Johansson, a founding member, helped establish Hammarby's strong community ties. Skoglund, renowned for his skill on the ball, became a symbol of the club's flair and ambition. Ohlsson, known for his dedication, embodied the team's fighting spirit. Together, they represent the essence of Hammarby Fotboll: a club built on passion, talent, and resilience.

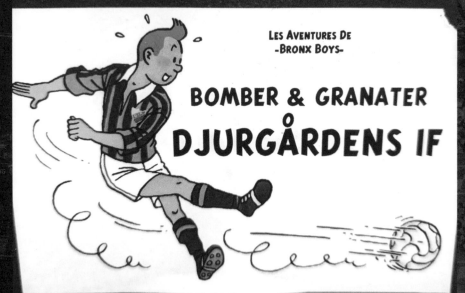

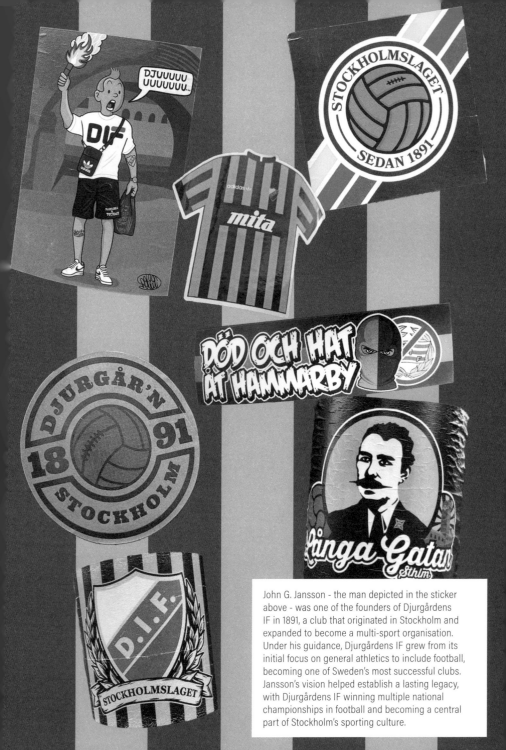

John G. Jansson - the man depicted in the sticker above - was one of the founders of Djurgårdens IF in 1891, a club that originated in Stockholm and expanded to become a multi-sport organisation. Under his guidance, Djurgårdens IF grew from its initial focus on general athletics to include football, becoming one of Sweden's most successful clubs. Jansson's vision helped establish a lasting legacy, with Djurgårdens IF winning multiple national championships in football and becoming a central part of Stockholm's sporting culture.

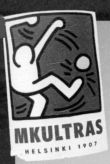

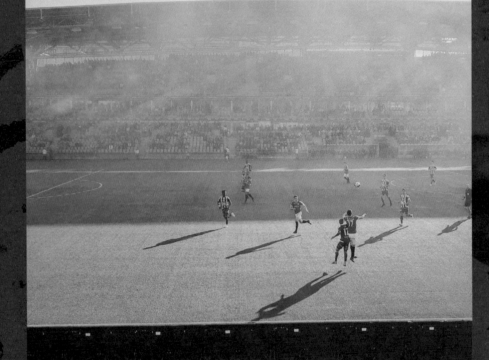

HJK Helsinki plays their home matches at the Bolt Arena, located in the heart of the city.

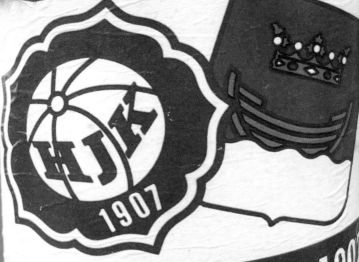

STADIN YLPEYS

VUODESTA 1907

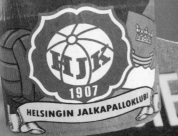

HELSINGIN JALKAPALLOKLUBI

HJK Helsinki, founded in 1907, competes in Finland's top football league, Veikkausliiga. HJK's main rival in Helsinki was widely considered to be HIFK, which was historically a Swedish-speaking club at a time when HJK supported the Finnish language and independence. HJK is the sole Finnish club to reach the UEFA Champions League group stage, achieved in 1998 after defeating Metz in a play-off.

"Kamraterna"
In the 1980s, IFK Göteborg defied the elite's scepticism by winning against giants like Barcelona in the UEFA Cup, a victory emblematic of the "kamraterna", the comrades' spirit. This narrative, from their grassroots to UEFA Cup triumphs, echoes IFK Göteborg's ethos of solidarity and collective strength, highlighted by legends like Torbjörn Nilsson.

Göteborg

Probably the best team in the world

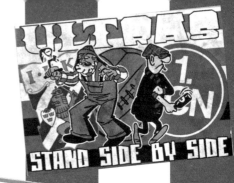

ULTRAS

STAND SIDE BY SIDE

KAMRATERNA

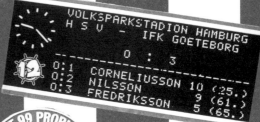

VOLKSPARKSTADION HAMBURG
H S V - IFK GOETEBORG

0 : 3

0:1 CORNELIUSSON 10 (25.)
0:2 NILSSON 9 (61.)
0:3 FREDRIKSSON 5 (65.)

WE GOT 99 PROBLEMS...
BUT FISH AIN'T ONE

I.F.K

IFKGBG
WORLD TOUR

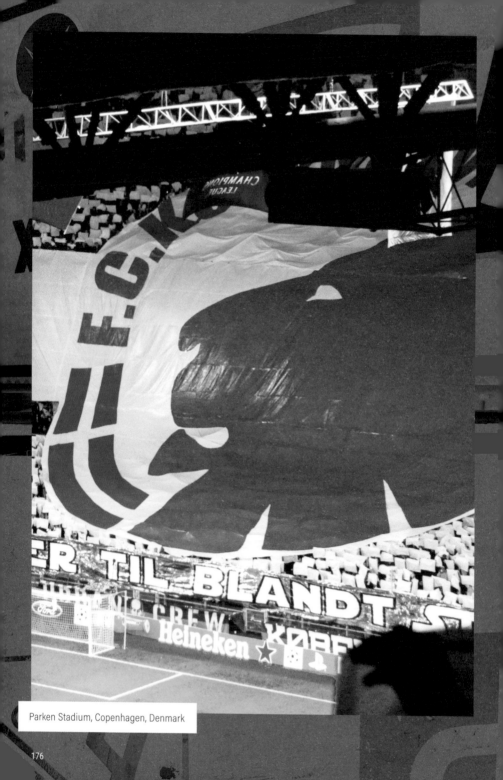

Parken Stadium, Copenhagen, Denmark

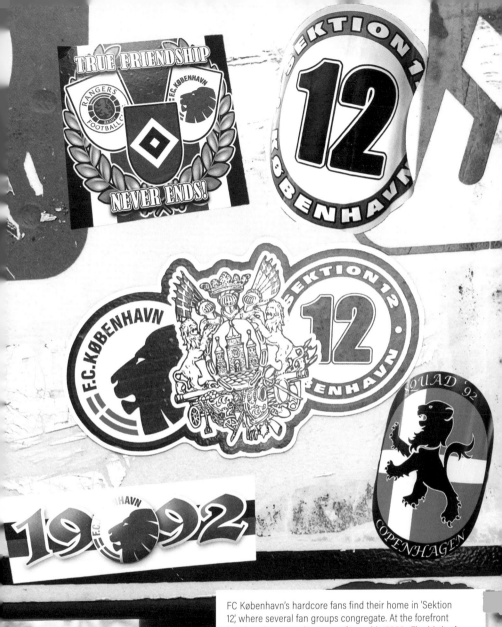

FC København's hardcore fans find their home in 'Sektion 12', where several fan groups congregate. At the forefront is Urban Crew, an ultra-group formed in 2003. The birth of FC København (FCK) in October 1991 marked a significant moment in Danish football history. The merger of two Copenhagen clubs, Kjøbenhavns Boldklub and Boldklubben 1903, created a powerhouse in Danish football. Kjøbenhavns Boldklub, in particular, boasted an illustrious history, with 15 league titles to their name and a legacy dating back to 1876, making them one of the oldest teams in continental Europe.

1910

MALMØ
1910

M·F·F

SUBKULTUR

Malmö FF are one of the most decorated clubs in
Sweden. The sticker on the right reads 'Success,
Pride and History' and depicts Malmö's rivalry with
AIK (Stockholm) and IFK Göteborg. These clubs are
collectively known as the Big Three of Swedish football.

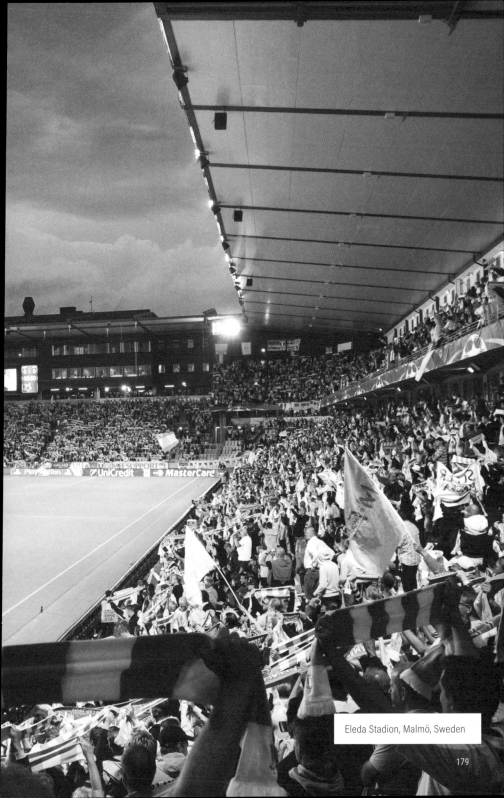

Eleda Stadion, Malmö, Sweden

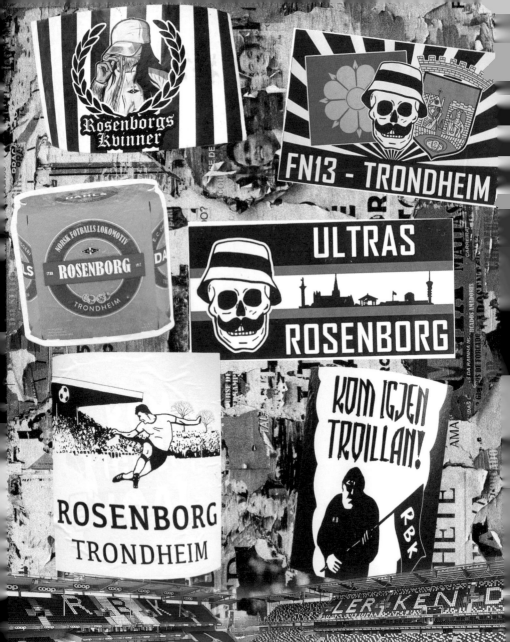

Lerkendal Stadion, Trondheim, Norway

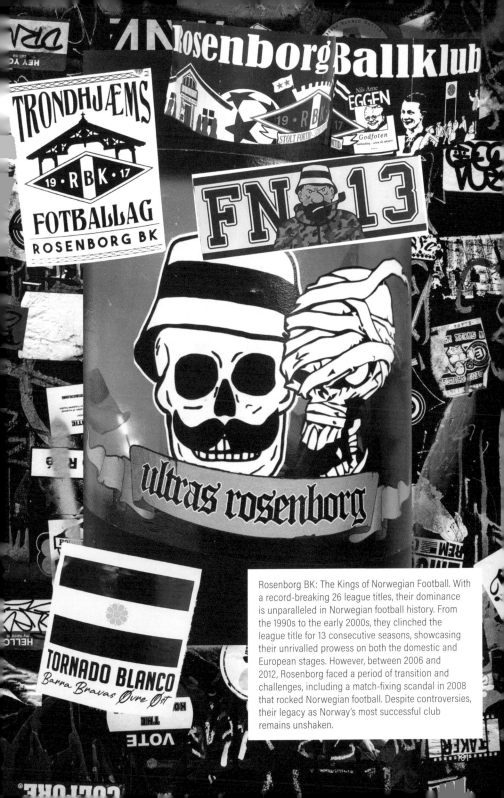

Rosenborg BK: The Kings of Norwegian Football. With a record-breaking 26 league titles, their dominance is unparalleled in Norwegian football history. From the 1990s to the early 2000s, they clinched the league title for 13 consecutive seasons, showcasing their unrivalled prowess on both the domestic and European stages. However, between 2006 and 2012, Rosenborg faced a period of transition and challenges, including a match-fixing scandal in 2008 that rocked Norwegian football. Despite controversies, their legacy as Norway's most successful club remains unshaken.

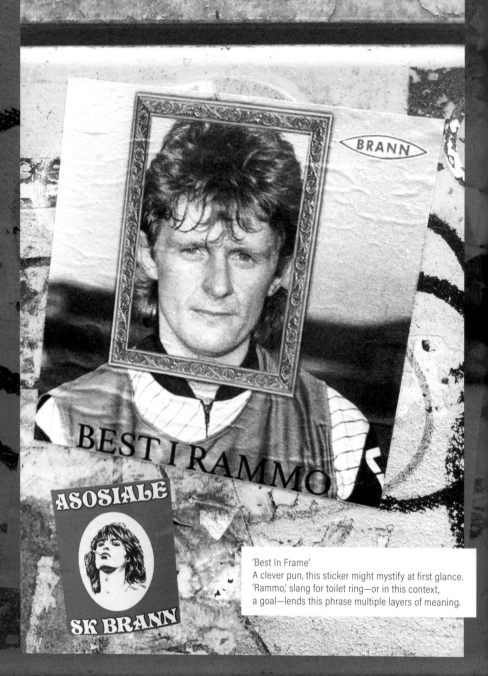

'Best In Frame'
A clever pun, this sticker might mystify at first glance.
'Rammo,' slang for toilet ring—or in this context,
a goal—lends this phrase multiple layers of meaning.

brann

Bergen

GANJA YOUTH

BRANN

SK BRANN

SKB youth

SK BRANN

BERGEN

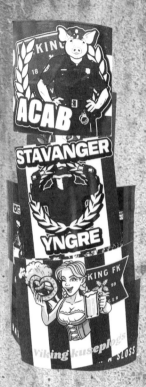

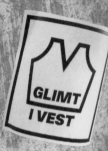

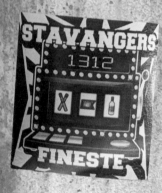

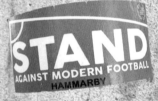

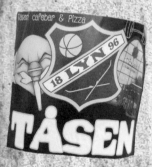

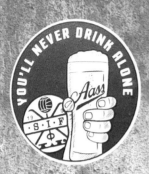

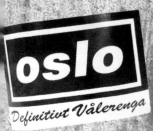

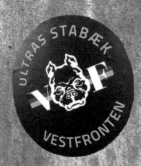

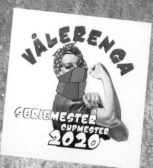

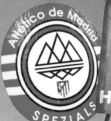
Atlético de Madrid
SPEZIALS

HIBERNIAN

THE PRIDE OF BCN

THE PRIDE OF EAST ANGLI

ON THE BALL SINCE 1902

Barça

ZWOLLE
S P Z L

IMBASTISCI
ON TOUR

anderlecht

CHELSEA SPEZIALS

CHELSEA FOOTBALL CLUB

OVER LAND AND SEA

THE NORTH STAND

WEST LONDO

PRIDE OF THE MIDLANDS

adidas
ORIGINALS

AVFC

THE VILLA BOYS
FROM ASTON

JFC CASUALS BASEL

liverpool
ORIGINALS

everton

OLDHAM ATHLETIC
SPEZIAL

Malmö

A NOTE ON...
THE CASUALS AND BRANDS

Casual culture within football represents a fascinating confluence of sport, fashion, and subcultural identity.

Originating in the late 1970s, this movement was pioneered by football fans who distinguished themselves through a distinctive choice of apparel, favouring high-end European designer brands over the traditional team colours and scarves. This shift was not merely aesthetic but emblematic of a broader socio-cultural phenomenon that intertwined the fervour for football with a nuanced expression of individual and collective identities.

At the heart of Casual culture lies a deep-rooted allegiance to specific fashion brands, with Adidas, Stone Island, Sergio Tacchini, and Lacoste among the most revered. These brands, initially popularised by football fans returning from European matches with previously unseen sportswear, became synonymous with the Casual identity.

Fashion within Casual culture was not just about the labels but the specific items - trainers, polo shirts, track jackets - and how they were worn. However, the role of branding in Casual culture cannot be overstated. Brands became badges of honour, symbols of status and allegiance that transcended their commercial origins to embody the values and identity of the Casuals.

This relationship between brand and identity was reciprocal; as Casual culture adopted these brands, it imbued them with new meanings and associations, transforming them into cultural icons on and beyond the terraces.

Stickers, as an extension of Casual culture, played a significant role in the visual and spatial dynamics of this subculture. Stickers acted as markers of territoriality, identity, and community. The imagery on these stickers often includes brand logos, subcultural symbols, or references to specific aspects of Casual culture. They were, and continue to be, used to claim space in urban environments, at away games, and in local haunts, while the act of 'slapping' them in visible locations serves as a form of communication and rivalry among different groups.

Through their distinctive choice of clothing and brands, Casuals have carved out a niche that goes beyond mere apparel, signifying a complex tapestry of social, cultural, and spatial practices. Stickers, as part of this cultural expression, offer a window into the values, rivalries, and camaraderie that define this movement, highlighting the intricate ways in which identities are constructed, contested, and communicated in the realm of football fandom.

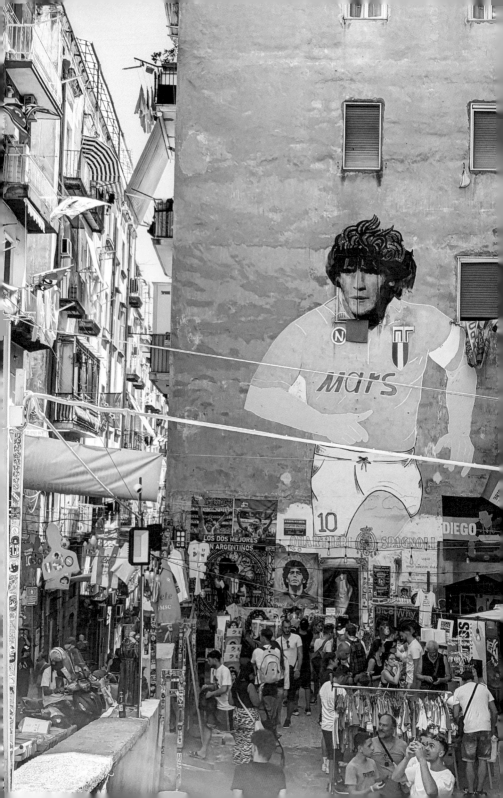

SOUTHERN EUROPE

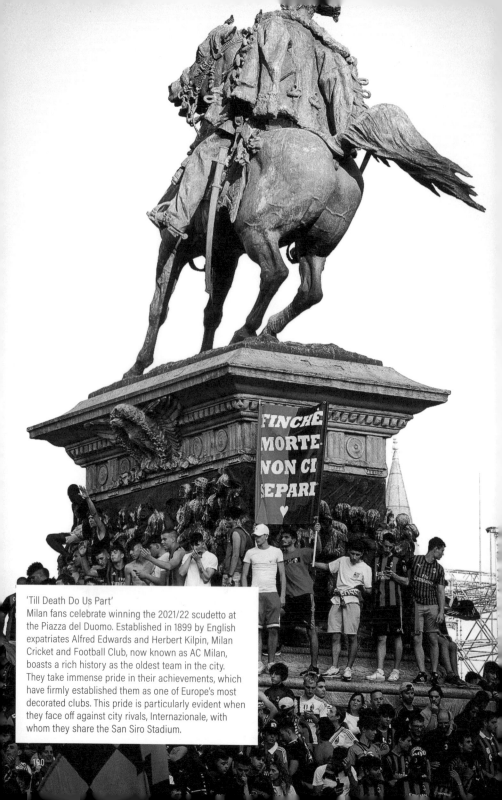

'Till Death Do Us Part'

Milan fans celebrate winning the 2021/22 scudetto at the Piazza del Duomo. Established in 1899 by English expatriates Alfred Edwards and Herbert Kilpin, Milan Cricket and Football Club, now known as AC Milan, boasts a rich history as the oldest team in the city. They take immense pride in their achievements, which have firmly established them as one of Europe's most decorated clubs. This pride is particularly evident when they face off against city rivals, Internazionale, with whom they share the San Siro Stadium.

NERVI
TESI

SCHILLACI
RUBA LE GOMME

CURVA SUD
MILANO

1 8
9 9

VECCHIA
MANIERA

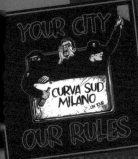

YOUR CITY

CURVA SUD
MILANO ON TOUR

OUR RULES

ARMATA

1989

AC Milan

COME NOI

ACM
1899

NESSUNO MAI

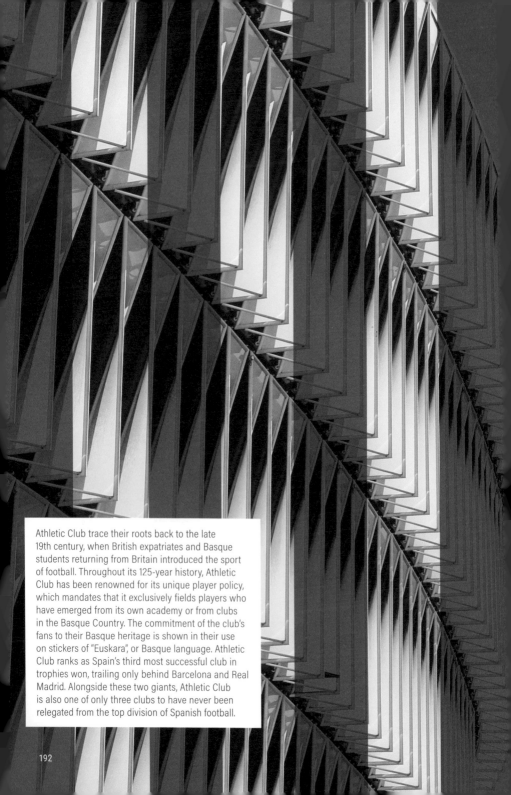

Athletic Club trace their roots back to the late
19th century, when British expatriates and Basque
students returning from Britain introduced the sport
of football. Throughout its 125-year history, Athletic
Club has been renowned for its unique player policy,
which mandates that it exclusively fields players who
have emerged from its own academy or from clubs
in the Basque Country. The commitment of the club's
fans to their Basque heritage is shown in their use
on stickers of "Euskara", or Basque language. Athletic
Club ranks as Spain's third most successful club in
trophies won, trailing only behind Barcelona and Real
Madrid. Alongside these two giants, Athletic Club
is also one of only three clubs to have never been
relegated from the top division of Spanish football.

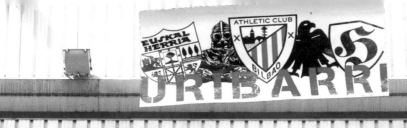

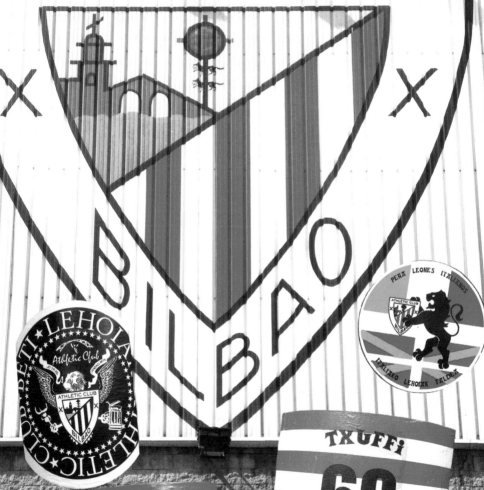

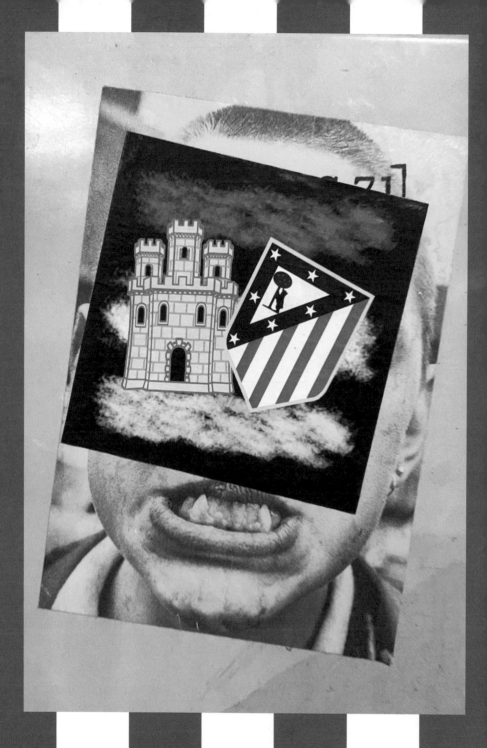

LEALTAD

NUESTRO

ESCUDO

ORGULLO DE LA CIUDAD

ESTANDARTE

DE MADRID

Atlético de Madrid

SPEZIALS

UNO DI NOI

'One Of Us'
The sticker features Atlético Madrid hero Fernando Torres, who turned his back on Real Madrid to support the club of his family. Another sticker declares the importance of "lealtad" (loyalty) to the club that feels itself overshadowed by its giant neighbour.

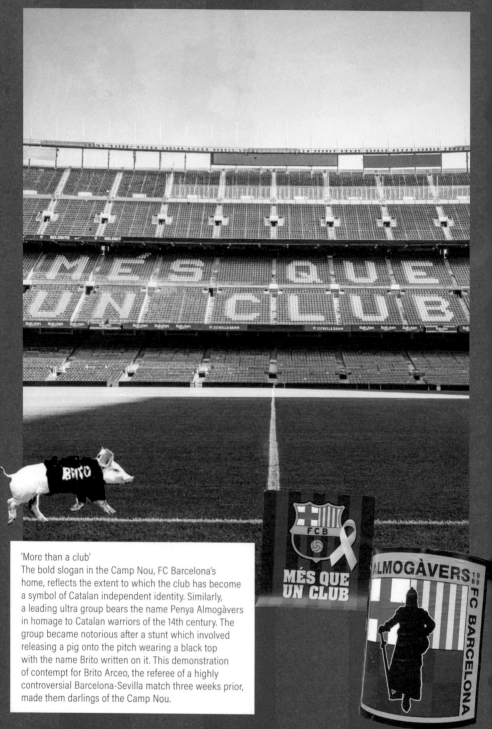

'More than a club'

The bold slogan in the Camp Nou, FC Barcelona's home, reflects the extent to which the club has become a symbol of Catalan independent identity. Similarly, a leading ultra group bears the name Penya Almogàvers in homage to Catalan warriors of the 14th century. The group became notorious after a stunt which involved releasing a pig onto the pitch wearing a black top with the name Brito written on it. This demonstration of contempt for Brito Arceo, the referee of a highly controversial Barcelona-Sevilla match three weeks prior, made them darlings of the Camp Nou.

Barça

ODIO ETERNO AL ESPANYOL

ON TOUR OLD TRAFFORD

Nostra Ensenya

Priva t'Anima

F.C.B.

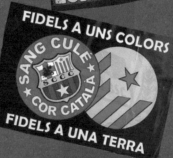

FIDELS A UNS COLORS

SANG CULÉ COR CATALÀ

FIDELS A UNA TERRA

THE PRIDE OF BCN

EXTERMINADORES DE RATAS

SIEMPRE ANTIMADRIDISTAS

PENYA BIZKABARÇA

SINCE 2009

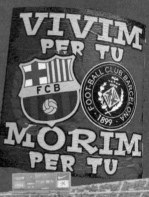

VIVIM PER TU

FCB

FOOT-BALL CLUB BARCELONA 1899

MORIM PER TU

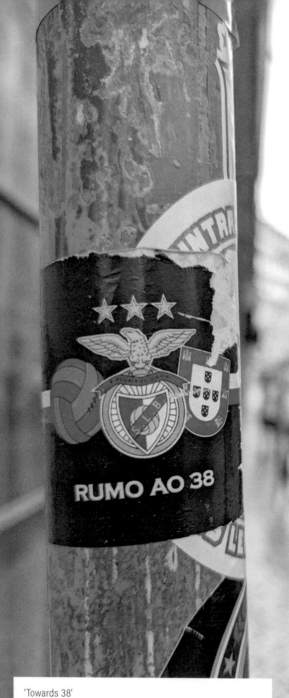

'Towards 38'
In 2023 Benfica won a record 38th Portuguese league title on the final day of the season beating Santa Clara 3-0.

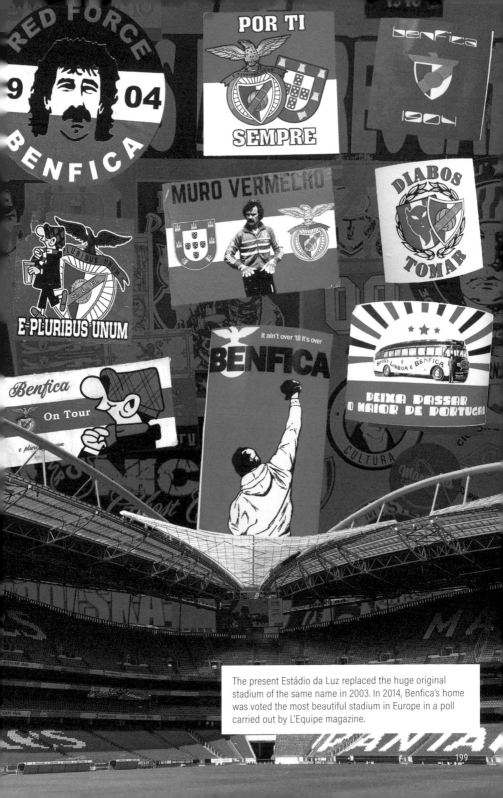

The present Estádio da Luz replaced the huge original stadium of the same name in 2003. In 2014, Benfica's home was voted the most beautiful stadium in Europe in a poll carried out by L'Equipe magazine.

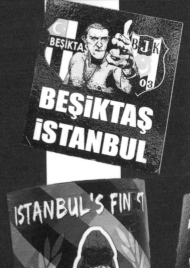

Beşiktaş, founded in 1903, is one of Turkey's big three clubs and one of the most successful, having never been relegated. It also is one of the few clubs permitted to include the Turkish flag in its crest.

'Our wine is better than your punch'

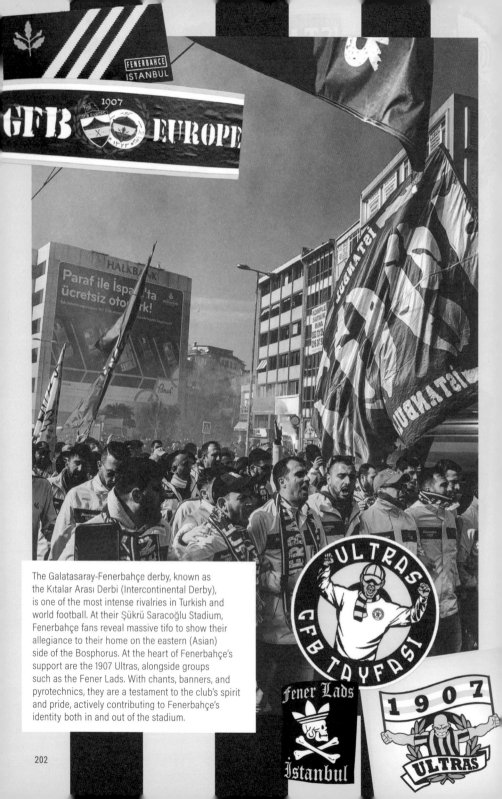

The Galatasaray-Fenerbahçe derby, known as the Kıtalar Arası Derbi (Intercontinental Derby), is one of the most intense rivalries in Turkish and world football. At their Şükrü Saracoğlu Stadium, Fenerbahçe fans reveal massive tifo to show their allegiance to their home on the eastern (Asian) side of the Bosphorus. At the heart of Fenerbahçe's support are the 1907 Ultras, alongside groups such as the Fener Lads. With chants, banners, and pyrotechnics, they are a testament to the club's spirit and pride, actively contributing to Fenerbahçe's identity both in and out of the stadium.

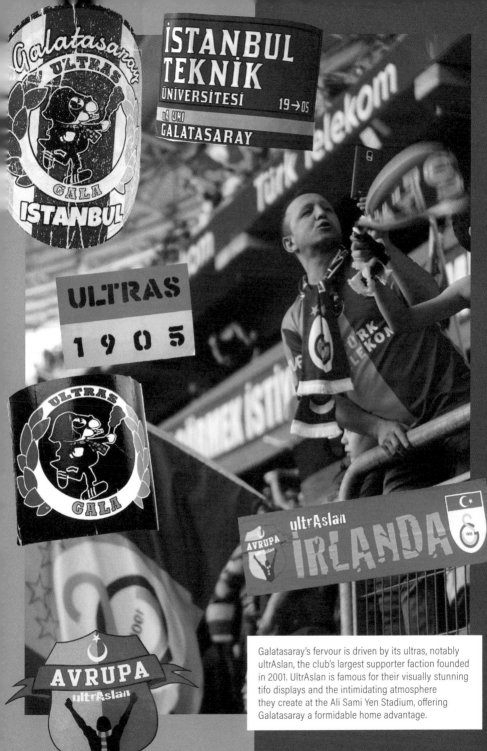

Galatasaray ULTRAS GALA ISTANBUL

İSTANBUL TEKNİK ÜNİVERSİTESİ 19→05
iÜ UNI GALATASARAY

ULTRAS 1905

ULTRAS GALA

ultrAslan AVRUPA İRLANDA

AVRUPA ultrAslan

Galatasaray's fervour is driven by its ultras, notably ultrAslan, the club's largest supporter faction founded in 2001. UltrAslan is famous for their visually stunning tifo displays and the intimidating atmosphere they create at the Ali Sami Yen Stadium, offering Galatasaray a formidable home advantage.

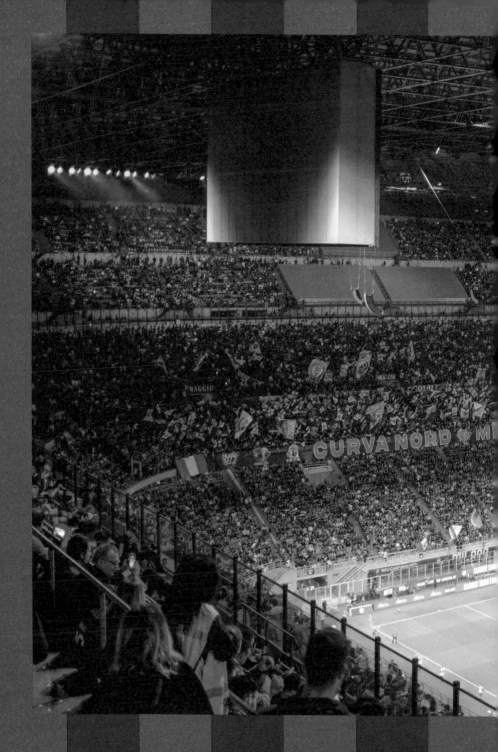

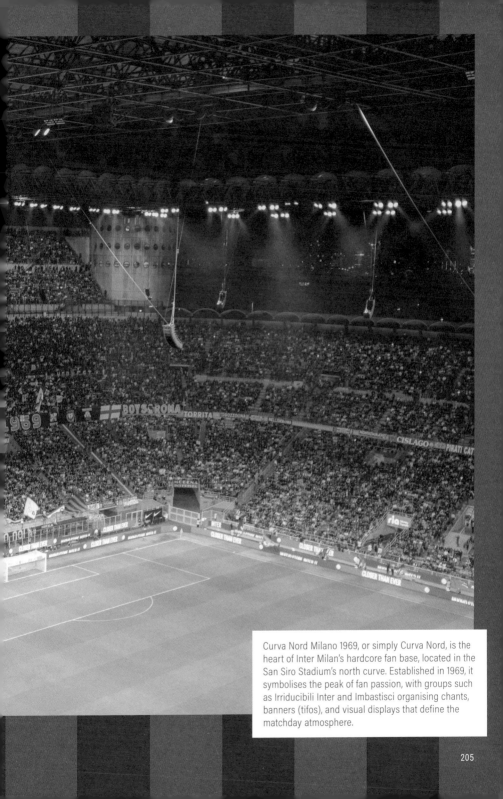

Curva Nord Milano 1969, or simply Curva Nord, is the heart of Inter Milan's hardcore fan base, located in the San Siro Stadium's north curve. Established in 1969, it symbolises the peak of fan passion, with groups such as Irriducibili Inter and Imbastisci organising chants, banners (tifos), and visual displays that define the matchday atmosphere.

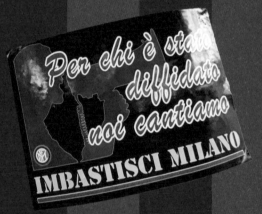

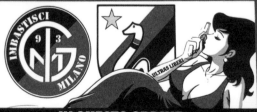

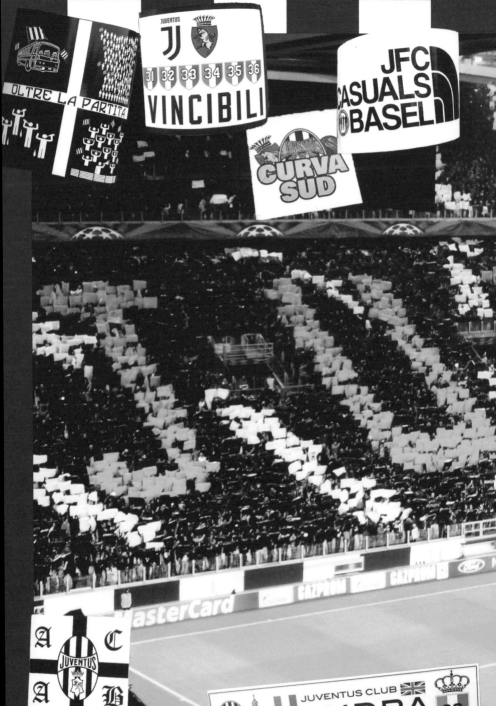

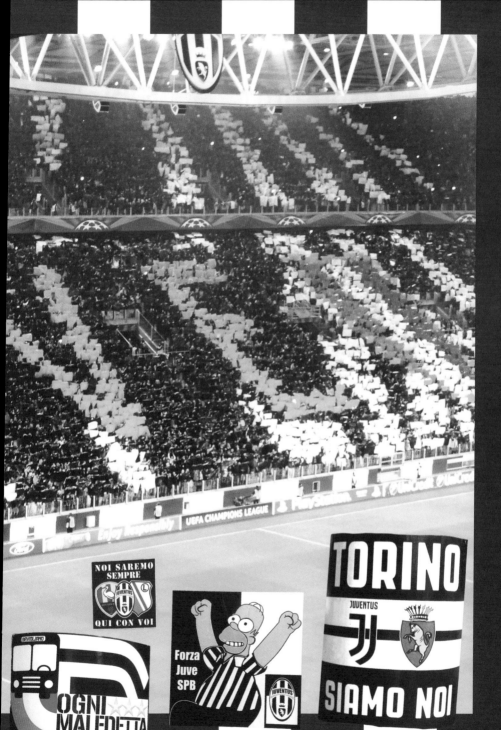

S.S. LAZIO

1900

zgA

LAZIO

S.S. Lazio

S.S.LAZIO

che Lazio !

**EACH CITY HAS
ITS OWN CLUB**

S.S. LAZIO

ROARING

LAZIO

TWENTIES

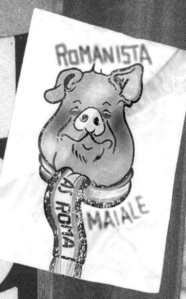

ROMANISTA

AS ROMA MAIALE

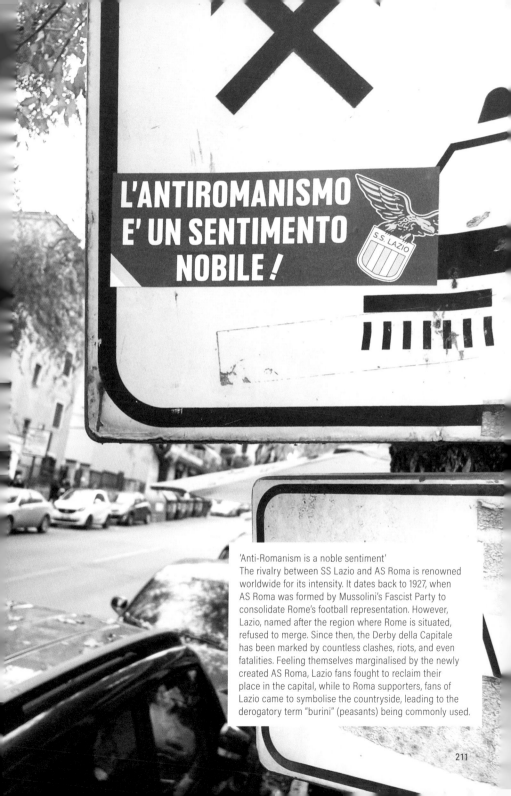

'Anti-Romanism is a noble sentiment'
The rivalry between SS Lazio and AS Roma is renowned worldwide for its intensity. It dates back to 1927, when AS Roma was formed by Mussolini's Fascist Party to consolidate Rome's football representation. However, Lazio, named after the region where Rome is situated, refused to merge. Since then, the Derby della Capitale has been marked by countless clashes, riots, and even fatalities. Feeling themselves marginalised by the newly created AS Roma, Lazio fans fought to reclaim their place in the capital, while to Roma supporters, fans of Lazio came to symbolise the countryside, leading to the derogatory term "burini" (peasants) being commonly used.

GABRIELE VIVE

ROMA TI PIANGE ANCORA!

'Rome still mourns you'
A stencil of Gabriele Sandri found in the Testaccio district of Rome, which is traditionally an AS Roma supporting neighbourhood.

Gabriele Sandri (1981-2007)

On November 11, 2007, Gabriele Sandri, a 26-year-old DJ and Lazio supporter, tragically lost his life in an incident that shook the Italian football community. Travelling with friends to a match in Milan, Sandri was seated in a car at the Badia al Pino service area near Arezzo when Lazio ultras attacked a group of Juventus supporters. When police attempted to intervene, one officer fired a shot that struck Sandri in the neck. This event spurred widespread outrage, igniting riots and prompting the cancellation of football matches across Italy. The unity shown in the aftermath, with fans from all clubs commemorating Sandri's life, underscored both the deep bonds within the Ultra community, and their enduring antagonism towards the police.

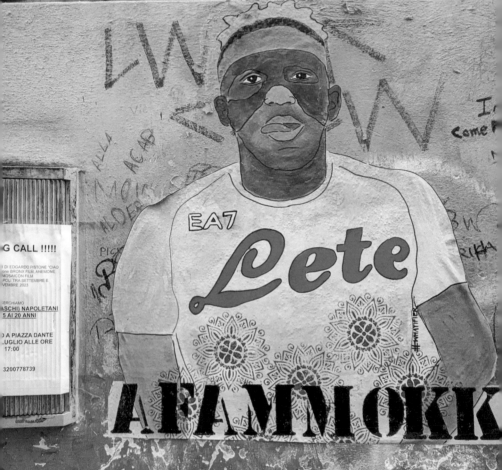

AFAMMOKK
This is Neapolitan slang expressing the euphoria of Napoli supporters at finally winning the scudetto in 2023 after a wait of 33 years. That season, Nigerian striker Victor Osimhen was top scorer in Serie A.

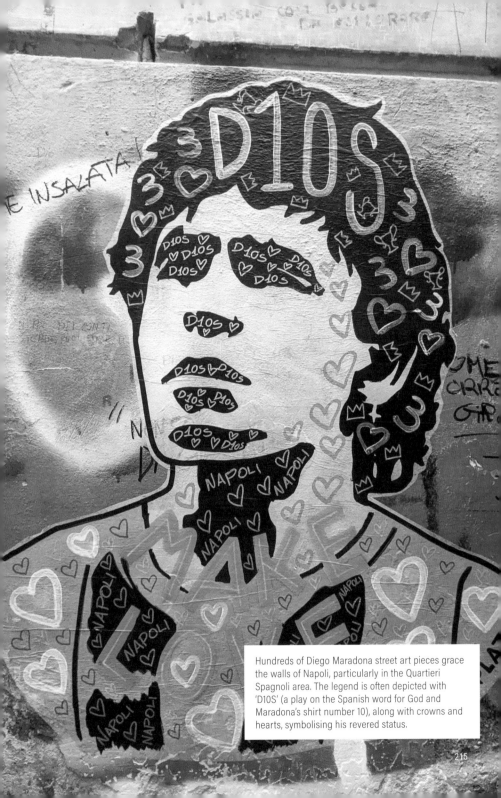

Hundreds of Diego Maradona street art pieces grace the walls of Napoli, particularly in the Quartieri Spagnoli area. The legend is often depicted with 'D10S' (a play on the Spanish word for God and Maradona's shirt number 10), along with crowns and hearts, symbolising his revered status.

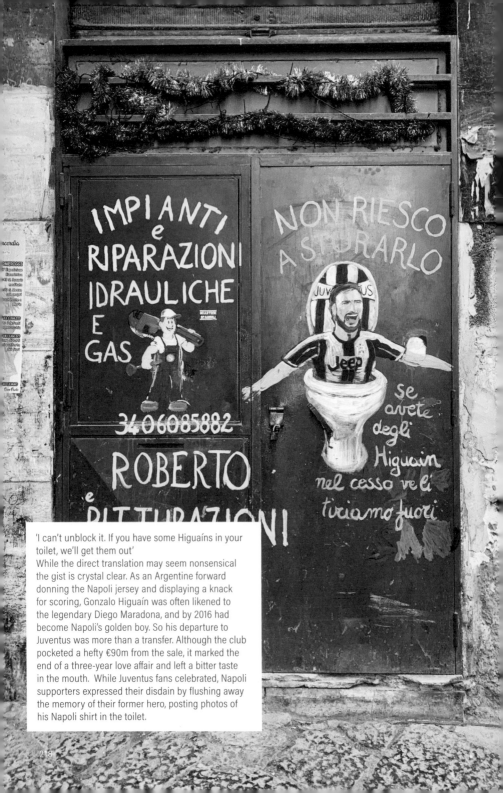

'I can't unblock it. If you have some Higuaíns in your toilet, we'll get them out'
While the direct translation may seem nonsensical the gist is crystal clear. As an Argentine forward donning the Napoli jersey and displaying a knack for scoring, Gonzalo Higuaín was often likened to the legendary Diego Maradona, and by 2016 had become Napoli's golden boy. So his departure to Juventus was more than a transfer. Although the club pocketed a hefty €90m from the sale, it marked the end of a three-year love affair and left a bitter taste in the mouth. While Juventus fans celebrated, Napoli supporters expressed their disdain by flushing away the memory of their former hero, posting photos of his Napoli shirt in the toilet.

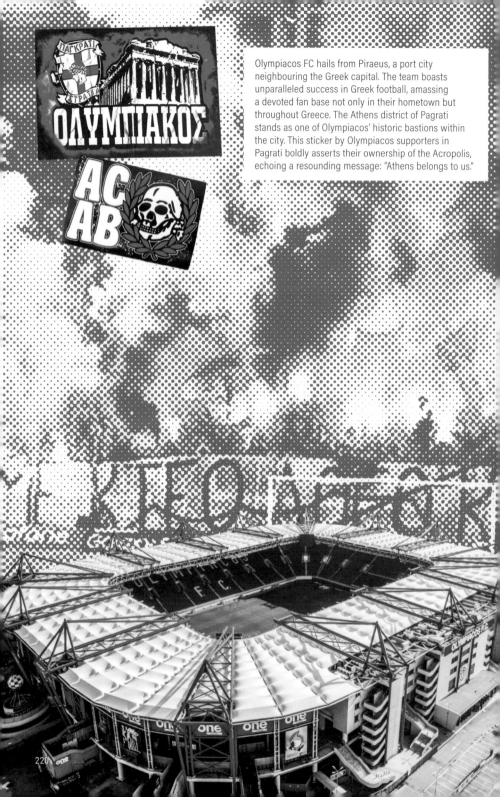

Olympiacos FC hails from Piraeus, a port city neighbouring the Greek capital. The team boasts unparalleled success in Greek football, amassing a devoted fan base not only in their hometown but throughout Greece. The Athens district of Pagrati stands as one of Olympiacos' historic bastions within the city. This sticker by Olympiacos supporters in Pagrati boldly asserts their ownership of the Acropolis, echoing a resounding message: "Athens belongs to us."

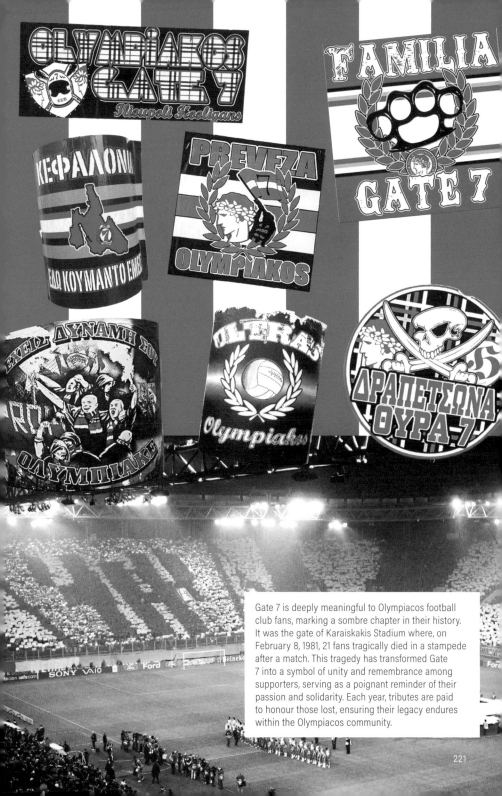

Gate 7 is deeply meaningful to Olympiacos football club fans, marking a sombre chapter in their history. It was the gate of Karaiskakis Stadium where, on February 8, 1981, 21 fans tragically died in a stampede after a match. This tragedy has transformed Gate 7 into a symbol of unity and remembrance among supporters, serving as a poignant reminder of their passion and solidarity. Each year, tributes are paid to honour those lost, ensuring their legacy endures within the Olympiacos community.

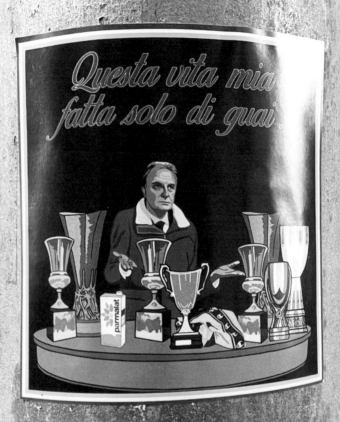

'This Life Of Mine Is Made Only Of Trouble.'
The sticker depicts Calisto Tanzi, the convicted
fraudster who was the founder of Parmalat and
owner of Parma football club. In the early 2000s,
Parmalat, once hailed as a global food empire,
collapsed in what became Europe's most colossal
bankruptcy, revealing a staggering €14 billion deficit
in its accounts. Tanzi's fall from grace was swift and
damning. In 2010, he faced the full weight of justice,
convicted of orchestrating a web of financial crimes
including market rigging and the false accounting
which ultimately led to Parmalat's demise. During
the 1990s, with generous backing from Tanzi, Parma
enjoyed multiple successes domestically and in
Europe, but these ended after the club was placed in
administration following the collapse of Parmalat. In
2015 the club declared bankruptcy and were forced to
re-form in Serie D. They currently play in Serie B.

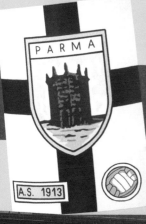

Stadio Ennio Tardini, home of Parma Calcio 1913

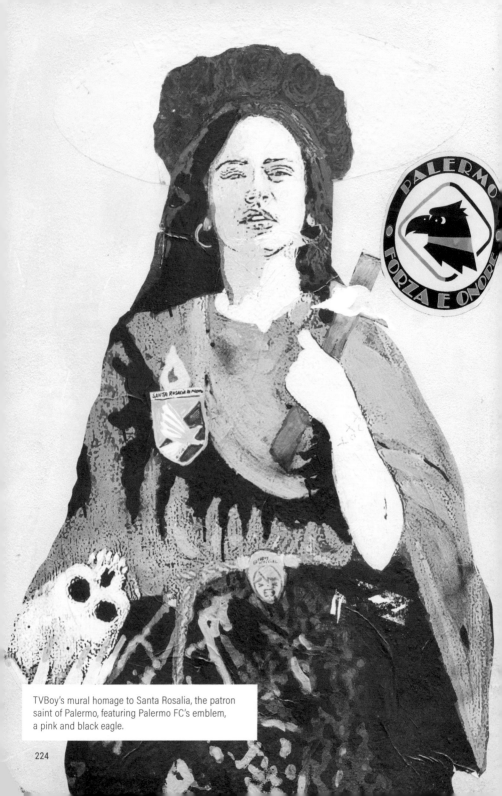

TVBoy's mural homage to Santa Rosalia, the patron saint of Palermo, featuring Palermo FC's emblem, a pink and black eagle.

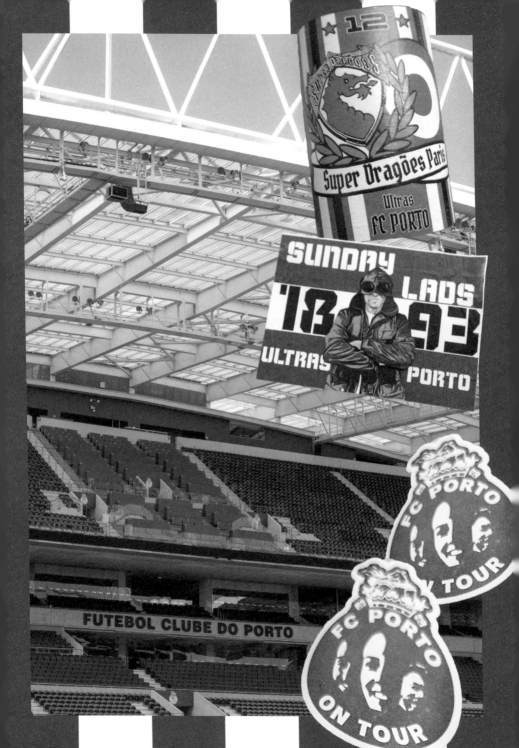

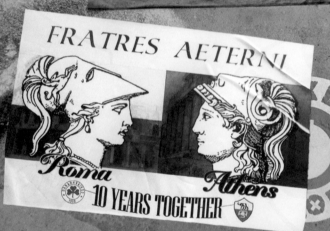

FRATRES AETERNI

Roma — Athens

10 YEARS TOGETHER

'Eternal Brothers'
This sticker symbolises the camaraderie between
Panathinaikos and AS Roma fans. The origins of
their friendship are debated: some trace it back
to a 2006 Champions League match in Greece
where Roma defeated Olympiacos, Panathinaikos'
arch-rival. Others attribute the bond to shared
experiences on the basketball court, while some
suggest the connection predates these events.
Nowadays, it's common to see Roma flags at both
Panathinaikos' football and basketball games,
showcasing the depth of their unity.

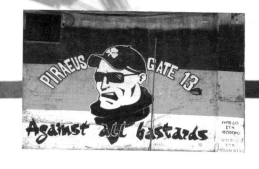

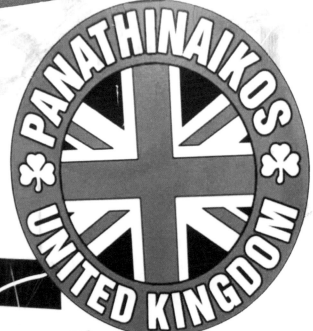

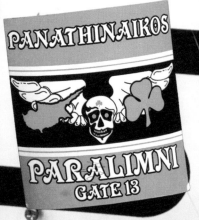

Gate 13 is the name of the supporters' group for Panathinaikos, one of the most historic and successful football clubs in Greece, based in Athens. Established in 1966, it is one of the oldest organised fan groups in Greek sports, and named after the gate of the Apostolos Nikolaidis Stadium, Panathinaikos' traditional home, through which the group's members enter. The supporters of Gate 13 are known for their passionate and fervent support of Panathinaikos, not only in football but also in basketball and other sports in which the club competes.

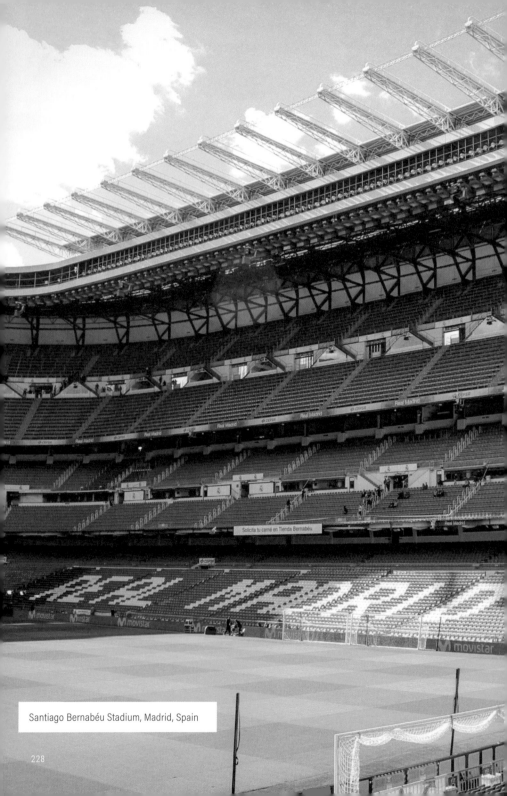

Santiago Bernabéu Stadium, Madrid, Spain

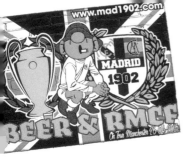

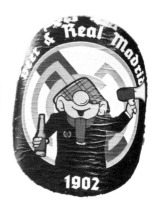

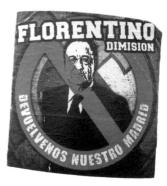

'Florentino Resign, Give Us Back Our Madrid'
For some Real Madrid fans, Florentino Pérez is seen as an arrogant billionaire criticised for his approach to managing Madrid's footballing legends and his relentless pursuit of the next superstar. However, others view him as a shrewd operator and an incredible businessman, acknowledging that the club remains strong and well-managed under his stewardship. Despite his successes, Pérez remains a divisive figure, highlighting the complexities and varied perspectives within the footballing community.

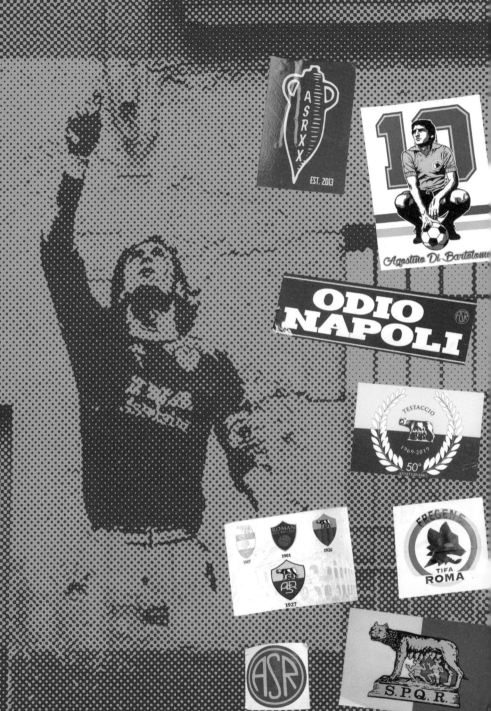

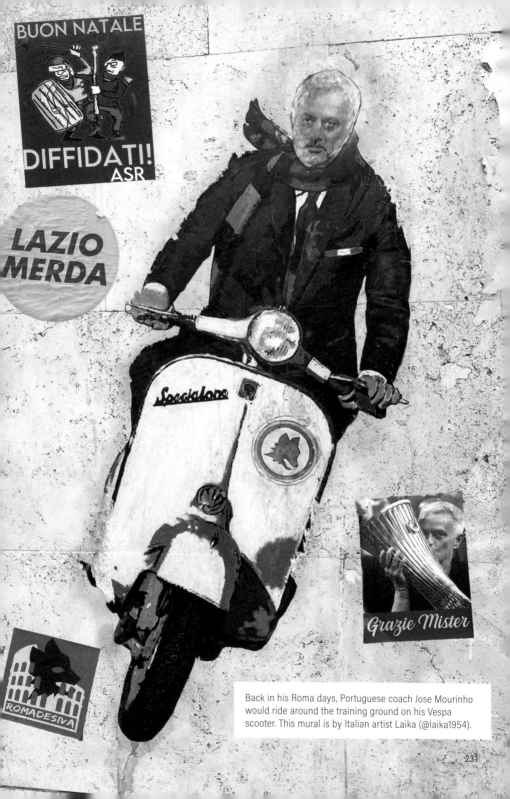

Back in his Roma days, Portuguese coach Jose Mourinho would ride around the training ground on his Vespa scooter. This mural is by Italian artist Laika (@laika1954).

231

A playful sticker spotted in Rome depicting a young AS Roma fan tripping a Lazio fan.

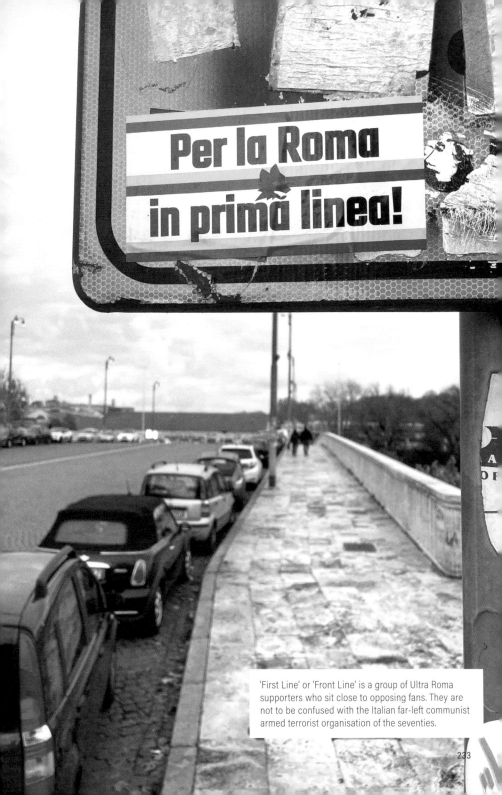

Per la Roma in prima linea!

'First Line' or 'Front Line' is a group of Ultra Roma supporters who sit close to opposing fans. They are not to be confused with the Italian far-left communist armed terrorist organisation of the seventies.

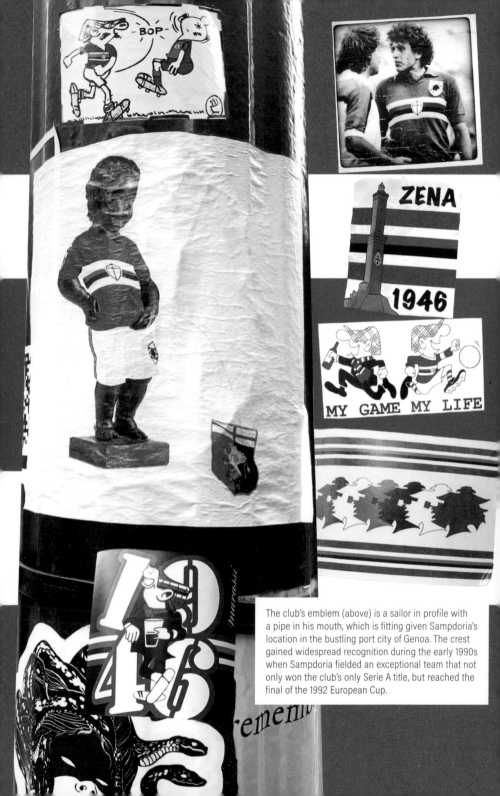

The club's emblem (above) is a sailor in profile with a pipe in his mouth, which is fitting given Sampdoria's location in the bustling port city of Genoa. The crest gained widespread recognition during the early 1990s when Sampdoria fielded an exceptional team that not only won the club's only Serie A title, but reached the final of the 1992 European Cup.

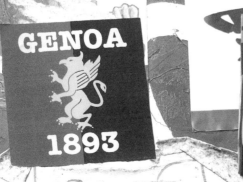

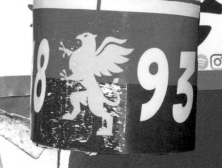

 ALBENGA

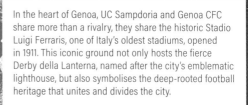

In the heart of Genoa, UC Sampdoria and Genoa CFC share more than a rivalry, they share the historic Stadio Luigi Ferraris, one of Italy's oldest stadiums, opened in 1911. This iconic ground not only hosts the fierce Derby della Lanterna, named after the city's emblematic lighthouse, but also symbolises the deep-rooted football heritage that unites and divides the city.

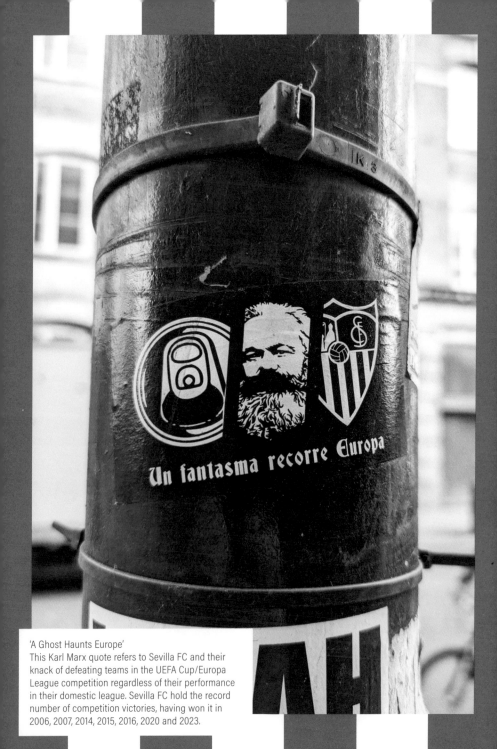

'A Ghost Haunts Europe'
This Karl Marx quote refers to Sevilla FC and their knack of defeating teams in the UEFA Cup/Europa League competition regardless of their performance in their domestic league. Sevilla FC hold the record number of competition victories, having won it in 2006, 2007, 2014, 2015, 2016, 2020 and 2023.

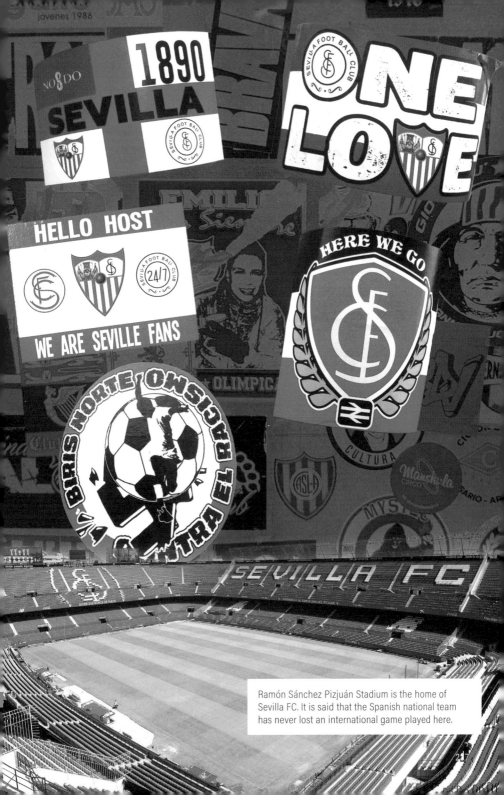

Ramón Sánchez Pizjuán Stadium is the home of Sevilla FC. It is said that the Spanish national team has never lost an international game played here.

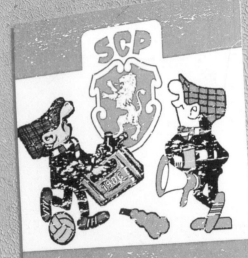

SPORTING ON TOUR

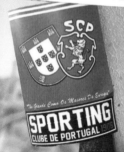

'On tour' stickers are frequently found in obscure locations. This sticker left by Sporting CP fans was spotted in a small town in Umbria, Italy.

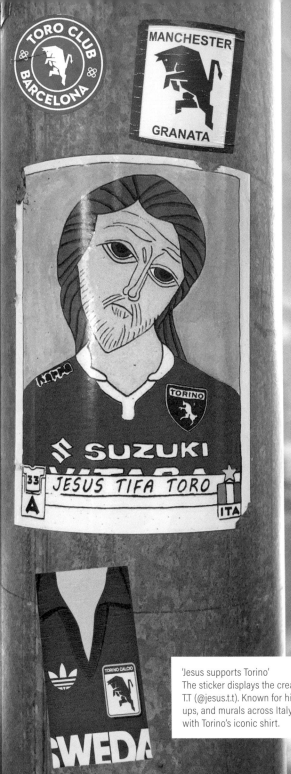

'Jesus supports Torino'
The sticker displays the creativity of street artist Jesus T.T (@jesus.t.t). Known for his vibrant stickers, paste-ups, and murals across Italy, he adorns public spaces with Torino's iconic shirt.

SOLO
ATALANTA

PAG

CESENA
SUPPORTERS

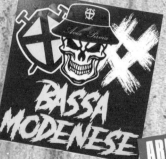

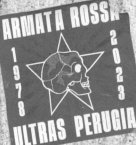

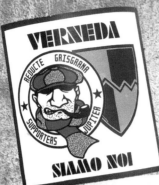

VERNEDA

REDUCTE GRISGRANA
SUPPORTERS JUPITER

SIAMO NOI

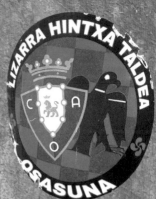

LIZARRA HINTXA TALDEA

C A
OSASUNA

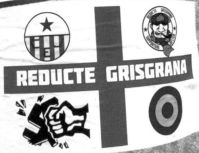

REDUCTE GRISGRANA

ULTRAS IRUN
ON TOUR

ODIO ETERNO AL FÚTBOL MODERNO

ULTRAS
VALLADOLID

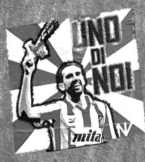

UNO DI NOI

mita

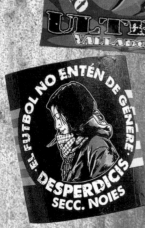

EL FUTBOL NO ENTÉN DE GÉNERE

DESPERDICIS
SECC. NOIES

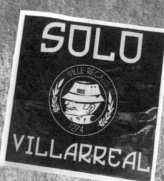

SOLO

VILLE REGALIS
1923
1274

VILLARREAL

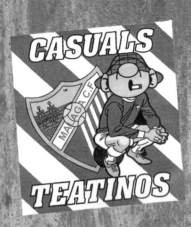

CASUALS
MALAGA CF
TEATINOS

UEDNOS

BOADILLA
SIEMPRE

FONDO DE BIKINI CREW
AGAINST MODERN FOOTBALL
A.D.R.V
EL PRESA VETE YA

ESTE AMOR
NO ES PARA COBARDES

Aniversario
Impresentables
2012 - 2022
#OnTour

TDB YOUTH
Celta Vigo

NO FAIR PLAY

RCD ESPANYOL
OVER LAND
AND SEA

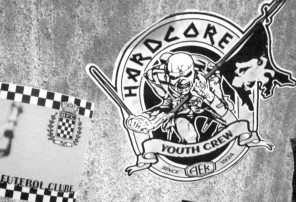

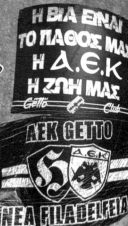

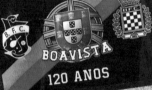

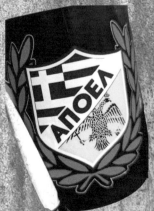

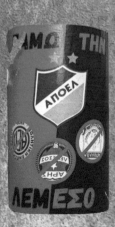

EXTRA TIME

Putting this book together has been a lot of fun and has reignited our love for scanning the urban landscape. We never realised how much football fans actually put their stickers up, in a manner so similar to how graffiti artists and street artists tag. Seeing St. Pauli stickers in the backstreets of Margate, Carlisle United stickers in Napoli, and Hansa stickers in Jakarta, Indonesia, has been quite the revelation.

It seems British, German, and Polish fan groups are the most prolific, but the Dutch and the Scandinavians are not too far behind, and Hungary seems pretty strong as well. Brussels is absolutely covered in Anderlecht and Union Saint-Gilles stickers, and there's been a lot of Sochaux and Frankfurt fans in Finsbury Park. Having compiled graffiti and street art books for years, our eyes are used to searching the streets for tags and stickers, but looking for football stickers is a lovely new hobby.

So, now we realise this book is just the kickoff, not the final whistle. There are a whole lot more football stories and fan-made art out there. With every sticker comes a story, and we've got plans for more of both. If you want to get involved, just check us out on socials, send us designs to go in future editions, and keep those stickers coming in.

Follow us @bombstagram. You can be part of this journey, part of a global squad united by love for the game and the art it inspires. Let's make this series a tribute to the unsung heroes, the fans, and the tales from the terraces.

PICTURE CREDITS

The publishers would like to thank the following sources for their kind permission to reproduce the pictures in this book.

Soi Books would like to thank
Laurence King, Adrian Greenwood and Steve Aston.

Ryo would like to thank Andrea di Crescenzo,
J. Xavier Chylinski, Matteo de Bellis, Simon Sanada,
Thiseas Poullos, and Enzo for being a great
sticker spotter on the long walks around Rome.

Suridh would like to thank Georgie for all the
publishing support. Everyone at Lydian Workspace,
Finsbury Park. Reza for helping me spot stickers
and Leah for her patience whilst on holiday.